Images of Modern America

AFRICAN AMERICAN
ST. LOUIS

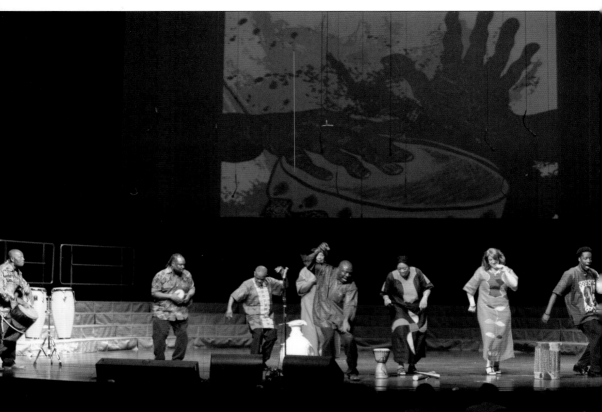

African Musical Arts is a nonprofit arts organization founded before 1994 to foster a better understating of Africa's cultures through the musical arts. Today, the mission of the organization is to meet the desire of an ever-growing audience to discover new modes of artistic expression. The group focuses on both choral and instrumental music by composers of African descent. (Courtesy of Fred Onovwerosuoke.)

FRONT COVER: A scene from *Black Nativity* by the Black Repertory Theatre (courtesy of Ron Himes).

UPPER BACK COVER: Urban League voter registration march in downtown St. Louis, 1960s (courtesy of St. Louis Metropolitan Urban League).

LOWER BACK COVER (from left to right): A dance group at the African Arts Festival in Forest Park (Courtesy of Cynthia Cosby), George Washington Carver statue and pond, Missouri Botanical Garden (courtesy of John A. Wright Jr.), Sweetie Pie's restaurant on Manchester Avenue (courtesy of Curtis Wright Sr.)

Images of Modern America

AFRICAN AMERICAN ST. LOUIS

John A. Wright Sr.
John A. Wright Jr.
Curtis A. Wright Sr.

ARCADIA
PUBLISHING

Copyright © 2016 by John A. Wright Sr., John A. Wright Jr., and Curtis A. Wright Sr.
ISBN 978-1-4671-1509-4

Published by Arcadia Publishing
Charleston, South Carolina

Printed in the United States of America

Library of Congress Control Number: 2015943993

For all general information, please contact Arcadia Publishing:
Telephone 843-853-2070
Fax 843-853-0044
E-mail sales@arcadiapublishing.com
For customer service and orders:
Toll-Free 1-888-313-2665

Visit us on the Internet at www.arcadiapublishing.com

*This book is dedicated to the children of the Wright family:
John Wright III, Anastasia Wright, Chloi Wright, Haley
Landre, Curtis Wright Jr., Clayton Wright, Caleb Wright,
Esana Wright, and Isabella Wright.It is our hope that St. Louis
continues working toward recognizing African Americans'
positive contributions to a better city and a better world.*

CONTENTS

Acknowledgments

Very special thanks go to Charles Brown and John Hoover of the Mercantile Library for their support and assistance, without which this project would not have gotten off the ground. Special thanks also go to Sarah Gottlieb, our editor at Arcadia Publishing, for her expert guidance when requested and prodding when needed. We also thank David Wright and Anastasia Wright for their encouragement and support. John Aaron Wright III, Carmel Wright, and Sylvia Wright are given our thanks for their assistance in reviewing and for their advice.

We want to thank the following individuals, organizations, and institutions that provided assistance, enabling the authors to accomplish this project: Hutchen Dixon, Michelle Price, Linda Brown Reed, Godwin Dorvlo, Larry Lewis, Kenneth Poole, Barbara Evans Cunningham, Michael Kodjo Anan Zoglo, Chajuana Trawick, Chauncey Trawick, Chloi Wright, Kelly Wright, Doris Wilson, Dorothy Squires, Miguel and Carla Alexander, Darleen Green, Donnell Reid, Darryl Jones, Dorothy Turner, Mary Tillman, Pam Nichaus, Doris Coleman, Isabella Wright, Fredia Wheaton, Betty Thompson, Annie Sue Berry, Robert Powell, Ida Early, Richard Scott, Basiyr Rodney, Arthur Perry, Richard White, Robert Green, JoAnn Adams Smith, Ernest Jones, Sally Altman, Ishamael Lateef Ahmad, Lynn Jackson, John Bass, Diane White, Betty Wheeler, Ronald Wilson, Jacqueline Vanderford, Patrick Wallace, Donna Rogers Beard, Kimberly Norwood, Solomon Thurman, Cynthia Cosby, Carlton Mitchell, Joseph DuBose Jr., Ronn Himes, Henry Givens, Lois Conley, Gloria Shelton, Judy Bentley, Ronald Nichols, Ronnie White, George Draper, Judy Graper, Jimmy Edwards, Stefen Bradley, Clayvon Wesley, June and Ann Price, Tim Person, *Newsgram* (City of St. Louis), Ronald Jackson, Vitilas "Veto" Reid, Jerome Williams Jr., Earl Wilson, Marva Williams, Elijah Brown, Gail Brown, Hazel Erby, Lee Moss, Angela McCurry, Janet Ward, Cecilia Nadal, Sigma Pi Phi fraternity, City of St. Louis, African Arts Festival, 100 Black Men, Shira Truitt, Black Leadership Roundtable, CHIPS, St. Louis Public Schools, Clayton School District, St. Louis University, Gary James, Kathy Surratt-States, Michelle Martin, Michelle Smart, Agnes Boldin, Gail Woods, Sidney Reedy, Cbabi Bayoc, Virvus Jones, Cheryl A.H. Watts, and Fred Onoverosuoke.

INTRODUCTION

African Americans have been a part of the St. Louis community since its founding and have played a vital role in shaping its history. There is no question that many of the wrongs that have plagued the African American community for years have not been fully eliminated. However, it must be recognized that progress has been made. The wretched occupants of the slave pens and county plantations that once existed could have hardly imagined a St. Louis that would elect two African American mayors, two police chiefs, a fire chief, a board of aldermen president, three comptrollers, and two treasurers, along with several aldermen. Nor could they have foreseen a St. Louis County with an African American county executive, and 30 communities with black mayors and leaders. It would also have been hard for them to imagine African American university presidents; corporate executives; streets, parks, and buildings bearing the names of African Americans; and nationally known African American entertainers performing before white audiences with contracts for large salaries.

The city we enjoy today did not come by chance. It came about through the struggle and efforts of many who went to court, went to jail, lost their jobs, spent days on the picket line, staged sit-ins, and engaged in civil disobedience. In spite of their efforts, there are still too many people being left behind, without decent housing, unemployed, underemployed, undereducated, without quality health care, and living in unsafe neighborhoods.

African American religious institutions continue today as they have throughout the history of the country, providing a shelter in the storm. A number of the churches have gone beyond the building of greater facilities, providing spiritual guidance, investing in neighborhoods, and providing food and clothing for those in need. Some provide scholarships and are involved in the construction of living units. The African American community is very different from what it was 100 years ago—it is much more diverse. Today, it is comprised of Christians, Jews, Muslims, and nonbelievers, many working together and some separately, with one common goal: a better St. Louis.

A key foundation of any great community is its schools. African Americans look to the past with great pride in the legacy some of their institutions and leaders have left. For years, blacks fought for decent schools for their children. However, today, there is a major concern over the lack of success of schools in the African American community. While the schools play a major role in the success of children, the community must share some of the blame. It is a community problem when parents lose their jobs and are placed in jail for their inability to pay for traffic tickets; when children are unable to receive adequate health care and have to be absent from school; when kids are forced to raise themselves because parents have to work more than one job to make ends meet; when the schools lack adequate supplies and certified teachers; when streets are unsafe for children to travel to school. Nevertheless, the issue of failing schools and the pipeline to prison for many students who fall through the cracks must be addressed. For those who want a fast and easy solution to this tough and difficult problem, it must be remembered that it did not happen overnight, and that it is not just an African American problem. It is an American problem.

If someone were blindfolded and dropped off in particular neighborhoods, they would think they were in a third-world country. They would find themselves without decent housing, quality health care, and fresh food. Many communities have developed community gardens to help themselves obtain fresh vegetables for their families. This idea has caught on and is now being copied in several communities. A number of churches, seeing the need for decent housing, have developed living units for families and the elderly. Since the major hospitals have fled the African American communities, a number of health clinics have opened up to fill the void.

During the time of segregation, many African American communities were self-contained and had a number of businesses that catered to residents' needs. With integration, many of those businesses disappeared. However, many survived and can be seen alongside fairly new successful ones, providing service to the African American and greater community.

St. Louis is fortunate to have a number of African American cultural institutions and festivals. Since the history of African Americans is not taught or valued in a number of schools, these institutions and events play a major role in educating the community about the contributions made by African Americans. They also assist in bridging cultural differences and breaking down racial barriers.

The authors know it is impossible to capture the full story of the African American community, with all the events, organizations, and individuals that have played a major role in shaping present-day St. Louis. There just is not enough space in this volume. It is the authors' hope that others will be inspired to do research and continue developing the story.

As we go forward as a community, the challenge before us will be to build safe neighborhoods, quality schools and health care systems, equal employment opportunities, and equal justice under the law for all citizens. With the killing of Michael Brown, an unarmed black teenager, in Ferguson, Missouri, in 2014, the world is focused on the St. Louis area. How we respond to the call for change will determine how we will be remembered in history. We can repeat the past by giving limited attention to issues with the feeling "this too shall pass," hoping and praying that the issues brought out by Ferguson will fade away. Or, we can join hands as a community to work for a better tomorrow so that the future will not be like the past—a continuous struggle to make America live up to its democratic ideals.

One

A Season of Change

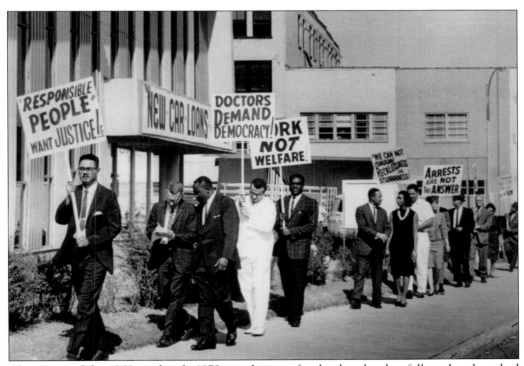

The events of the 1960s and early 1970s set the tone for the decades that followed and marked major turning points in the city. In 1963, the Congress of Racial Equality demonstrated at the Jefferson Bank & Trust Company over the issue of jobs. This event is considered by many as the beginning of the civil rights movement in St. Louis. (Courtesy of the Mercantile Library.)

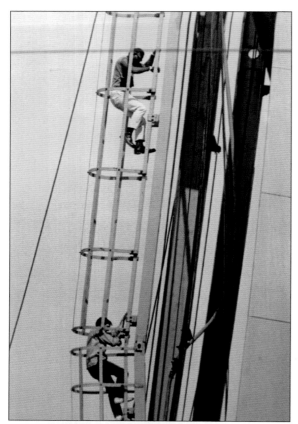

On July 14, 1964, Percy Green (top) and Richard Daly (bottom) drew national attention to the lack of African American employment in the construction of the Gateway Arch by climbing a ladder on the outside of the unfinished structure and chaining themselves to it. This event led to one of the earliest high-profile test cases by the federal government regarding equal employment for African Americans. (Courtesy of the Mercantile Library.)

Ivory Perry was a civil rights champion who led the cause to eliminate lead poisoning for St. Louis residents. While working for the Human Development Corporation, he found that blacks living in substandard housing had recurring health issues related to lead-based paint. In 1970, with aldermanic help, Perry got an ordinance passed forcing landlords to remove lead-based paint from their properties. (Courtesy of the Mercantile Library.)

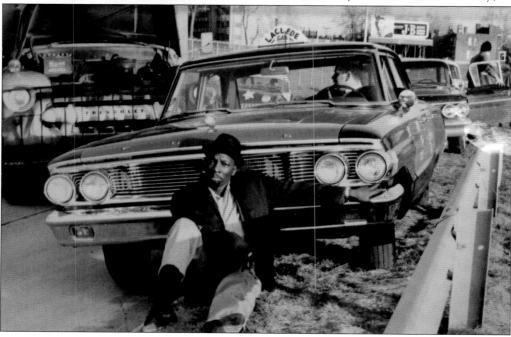

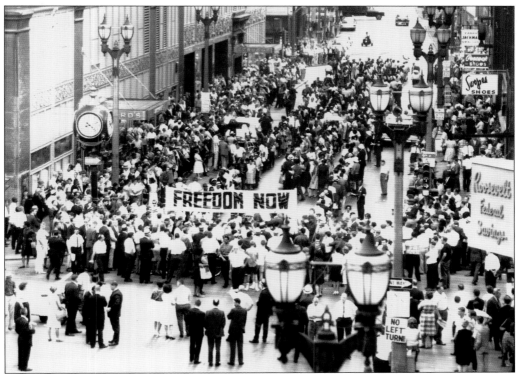

The NAACP organized a demonstration in June 1963 in front of the board office at 911 Locust Street, demanding total integration of St. Louis Public Schools. The district was engaged in a practice of busing black students from overcrowded black schools to white schools. Once there, they were kept in a separate part of the building, with separate lunch and playground periods. (Courtesy of the Mercantile Library.)

In 1972, parent Minnie Liddell filed a successful class-action lawsuit against the Board of Education of the City of St. Louis for violating the 14th Amendment's Equal Protection Clause. Her actions served as a landmark event in the desegregation of the city's public schools and sparked the largest school-choice program in the United States at that time. (Courtesy of the Mercantile Library.)

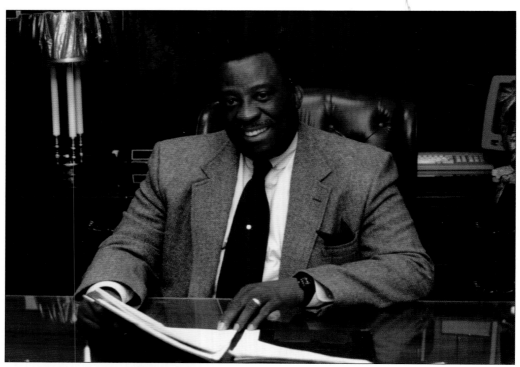

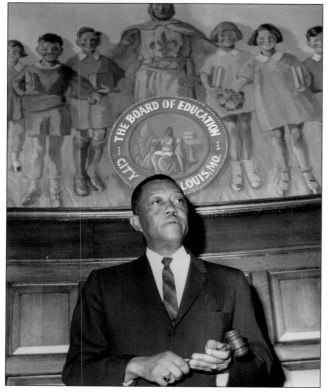

In 1975, Ernest Jones made history when he became the first African American to lead St. Louis Public Schools as interim superintendent. During his 29 years with the district, he served in a variety of positions, from classroom teacher to executive deputy superintendent. He left the district in 1980 to become superintendent of schools in Gary, Indiana. (Courtesy of Ernest Jones.)

In 1959, Rev. John Hicks became the first African American to be elected to citywide office when he ran and won a seat on the school board for the City of St. Louis. This step not only allowed for greater participation in education, but also acted as a beacon for others to pursue public-service avenues to give voice to change. (Courtesy of the Mercantile Library.)

This educational complex is dedicated to Dr. Samuel Shepard, director of the Banneker District of the St. Louis Public Schools from 1957 to 1976. His tenure was marked by the implementation of notable methods to inspire students to attend and excel in school. He also promoted parent involvement in their children's education. A nearby street is named in his honor. (Courtesy of John A. Wright Sr.)

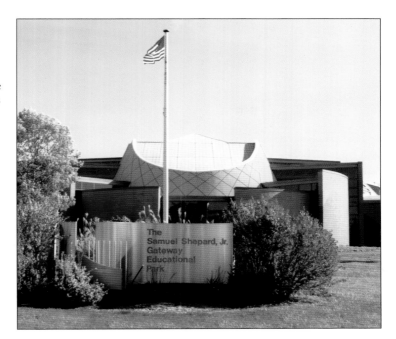

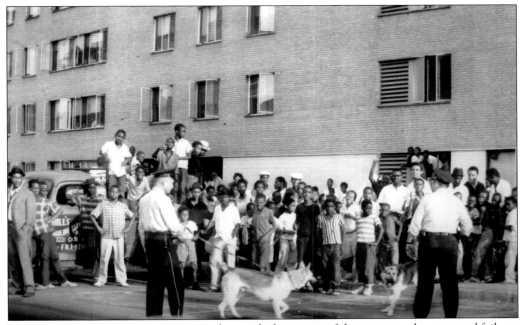

The Pruitt-Igoe housing projects were infamous for being one of the greatest urban-renewal failures in American history. From the beginning of its occupation, there were problems with maintenance, upkeep, and crime. By the end of the 1960s, Pruitt-Igoe was almost completely abandoned, leaving those who remained in dire circumstances. In 1971, the complex was evacuated, and the buildings were demolished. (Courtesy of the Mercantile Library.)

Toward the end of the 1950s, there were a number of black professionals, including doctors, dentists, educators, and realtors, who were interested in building homes outside of the Ville area. They worked together through straw parties, absentee landlords, and speculators to acquire 13 lots in Richmond Heights. White residents unsuccessfully held meetings to block housing developments. By the early 1960s, Bennett Avenue flourished. (Courtesy of John Wright Sr.)

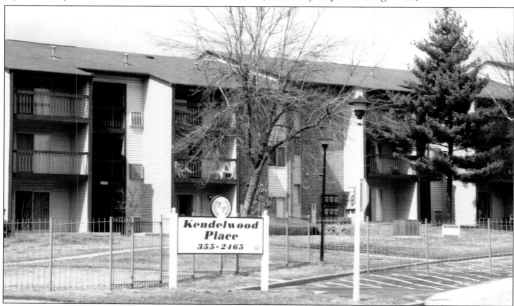

In 1970, the Inter-Religious Center for Urban Affairs proposed building a federally subsidized, moderate-income, multiracial housing project on Parker and Old Jamestown Roads. The residents protested, incorporated, and formed the City of Black Jack, passing a zoning code to block the project. The city lost in the courts and was forced to develop the housing units now known as the Kendelwood Apartments. (Courtesy of John A. Wright Sr.)

14

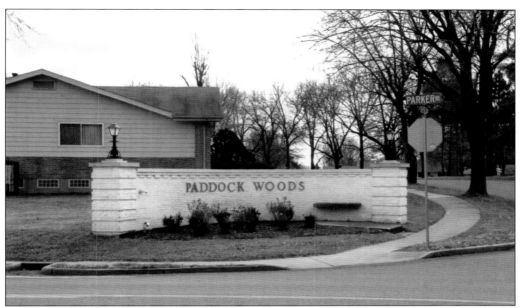

On September 2, 1965, Joseph Lee Jones filed a complaint in US District Court against the Alfred H. Mayer Company, contending that the company refused to sell him a home in the Paddock Woods subdivision because of his race. The case went to the US Supreme Court, which ruled 7-5 in Jones's favor, based on an 1856 antidiscrimination law regarding property sales. (Courtesy of John A. Wright Sr.)

The mid-1960s saw the chain and blockade on Suburban Avenue come down. The barriers barred entrance to the once all-white sundown town of Ferguson to blacks from Kinloch. This era also saw the closing of the small, segregated black elementary school operated by the Ferguson-Florissant School District in Kinloch, under pressure from the Missouri Human Rights Commission and residents. (Courtesy of John A. Wright Sr.)

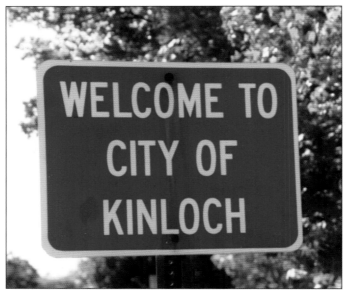

The area now known as the city of Kinloch was formed in 1937 when the white residents of the city incorporated their section into the city of Berkeley for the purpose of establishing a white-controlled, segregated school district. In 1975, a federal court ruled the maintenance of Kinloch schools unconstitutional and ordered that they be desegregated. Today, all the Kinloch schools are closed. (Courtesy of John A. Wright Sr.)

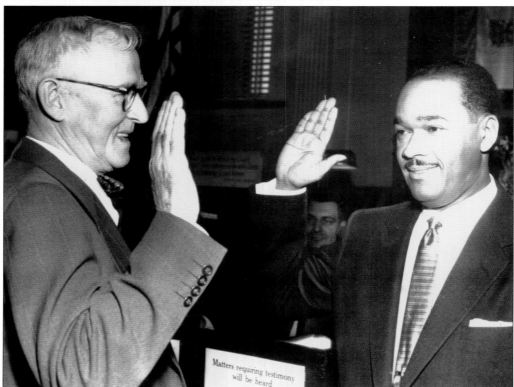

Judge Theodore McMillian broke down many racial barriers during his lifetime. In 1956, he became the first African American Missouri circuit judge in St. Louis. In 1972, he was the first African American appointed to the Missouri Court of Appeals, Eastern District. In 1978, McMillian was the first African American appointed to the US Court of Appeals for the Eighth Circuit. (Courtesy of the Mercantile Library.)

In 1960, Theodore McNeal became the first African American elected to serve in the Missouri Senate. Senator McNeal was active in union politics, having served on the staff of the Brotherhood of Sleeping Car Porters and Maids Union. He also served on the University of Missouri Board of Curators and was a past president of the Board of St. Louis Police Commissioners. (Courtesy of Betty Wheeler.)

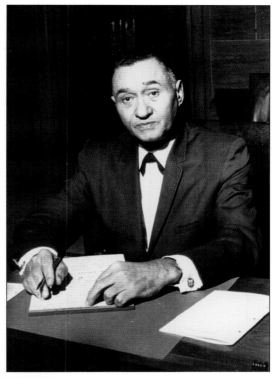

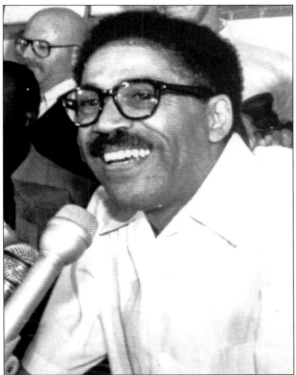

Congressman William Clay Sr. began his political career as an alderman very active in the struggle for civil rights in St. Louis. He spent 112 days in jail for his participation in demonstrations against the hiring practices of Jefferson Bank. In 1968, Clay won the Democratic primary and the general election, making him Missouri's first black elected member of the US Congress. (Courtesy of the Mercantile Library.)

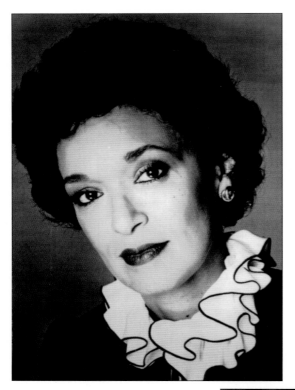

Dianne White was a pioneer who broke down racial barriers in St. Louis when she became the first African American meteorologist in the nation. Her career at television station KSDK spanned more than 26 years, during which she also presented feature stories and headline news. In addition to her on-camera talent, White was also the first African American model at several major St. Louis department stores. (Courtesy of Dianne White.)

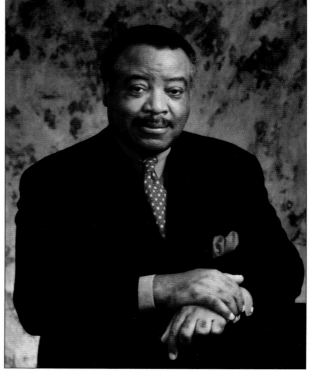

Julius Hunter broke down racial barriers, becoming St. Louis's first black television anchor in 1966. He held the position until 1974 at KSDK, News Channel Five. Hunter is best known as the senior anchor at KMOV-TV. During his stellar career, he interviewed five incumbent presidents and traveled to Rome with Pope John Paul II. Hunter authored several books and has conducted the St. Louis Symphony Orchestra. (Courtesy of Julius Hunter.)

Former St. Louis Cardinals player Curt Flood forever changed Major League Baseball when he challenged the league owners' ability to trade players to other teams. Flood demanded his rights, refusing to be traded. He took his case to the Supreme Court, where he ultimately lost. However, his case led to solidarity for the players, who would fight the reserve clause and win free agency. (Courtesy of the Mercantile Library.)

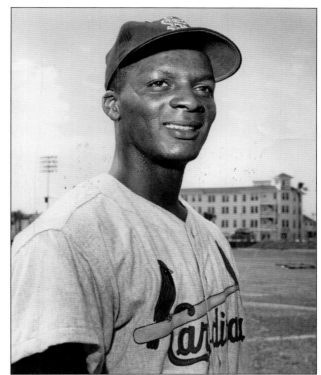

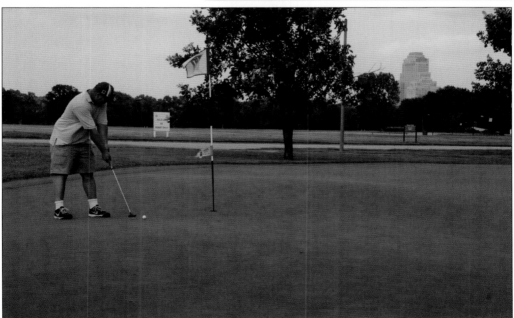

Today, all public golf courses are open to everyone regardless of race. At one time, African American golfers were only allowed to play on Mondays from 6:00 a.m. to noon in Forest Park. A whistle would blow at the end of the period, and black golfers were expected to leave the course. The Monday morning rule was waived in 1940. (Courtesy of John A. Wright Sr.)

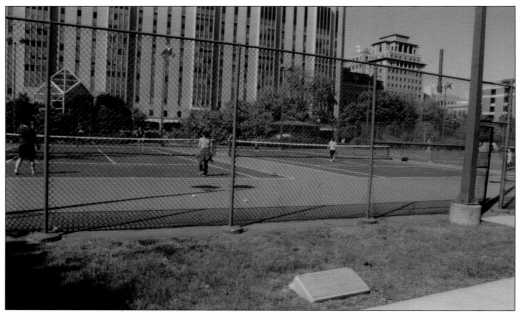

In 1976, the tennis courts in the southeast section of Forest Park were named to honor Richard Hudlin, a Sumner High School social studies teacher and tennis coach. Hudlin filed a lawsuit in an attempt to compete in the city's tennis championship held in the park. The court stated it had no power to intervene because the tournament was run by a private agency. (Courtesy of John A. Wright.)

Prior to 1960, most cemeteries that accepted African Americans, like St. Peters (pictured), laid them to rest in a special section reserved for blacks and other people of color. Like most of the St. Louis cemeteries, hospitals, restaurants, movie theaters, playgrounds, hotels, amusement parks, and other establishments, segregation was the rule of the day. (Courtesy of John A. Wright.)

Elisha Brown, founder of Brown Kortkamp Moving & Storage Company, is pictured here with his daughter, company president Gail Brown, in their staff conference room. Brown formed Brown & Brown Realty Company in 1960, with a goal of offering a wide spectrum of services. When he was unable to obtain a license to provide moving services, Brown acquired Kortkamp Moving Company. (Courtesy of John A. Wright Sr.)

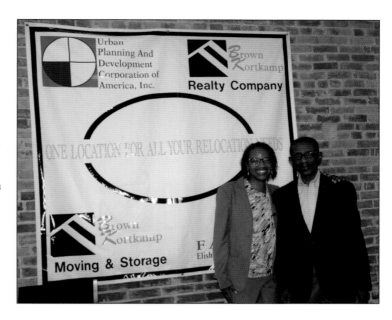

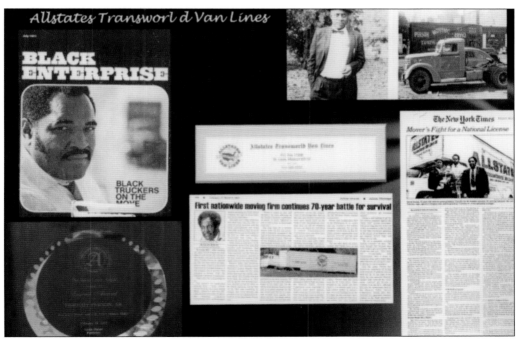

Allstate Transworld Van Lines had its beginning in 1929, when David Person began the family moving business. It was later taken over by his son Timothy, who began a battle to obtain an interstate moving license in 1964. The fight lasted until 1981, when Allstate Transworld became the first black company to obtain a license, one of 20 such companies in America. (Courtesy of Tim Person.)

The theaters and restaurants along Grand Boulevard were segregated until the late 1950s and the early 1960s. Change was brought about through picketing and the 1961 public-accommodation ordinance by the City of St. Louis. In the mid-1950s, black and white children were allowed to go to the movies together during Brotherhood Week. (Courtesy of John A. Wright Sr.)

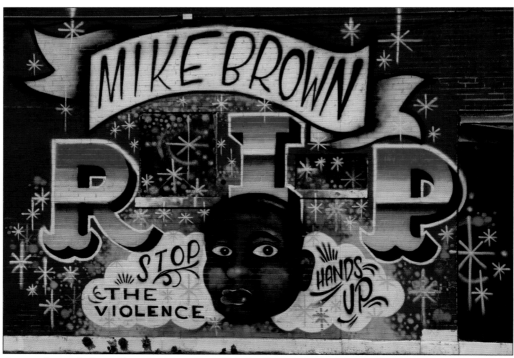

A mural was dedicated to the memory of Michael Brown, an unarmed teenager who was killed on August 9, 2014, by a white police officer in Ferguson, Missouri. Brown's death helped spark an international outcry for changes in policing African American communities. The mantra "Hands Up, Don't Shoot" was echoed around the country and was adopted by celebrities as a sign of solidarity for change. (Courtesy of John Wright Sr.)

Two

Education and
Recreation

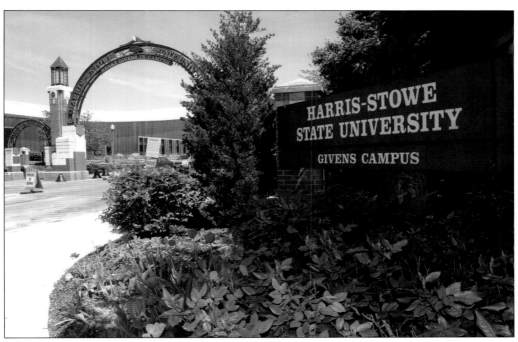

Educational and recreational facilities and institutions, along with other venues for learning and sports, have been an important part of the African American community since the founding of the city. Harris-Stowe State University came about through the merger of the once all-white Harris Teachers College and the all-black Stowe Teachers College in 1954. (Courtesy of Dr. Henry Givens Jr.)

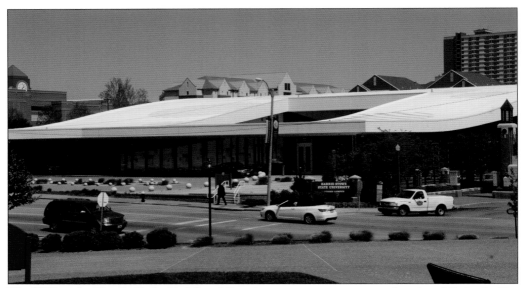

The William L. Clay Sr. Early Childhood Development center is a comprehensive, full-day facility for children six weeks to five years of age. This center's program is designed to encourage the social, emotional, physical, and cognitive development of a diverse population of children. It embraces their needs and their interests to explore, discover, experiment, and examine their world through play, and promotes the support and participation of parents. (Courtesy of John Wright Sr.)

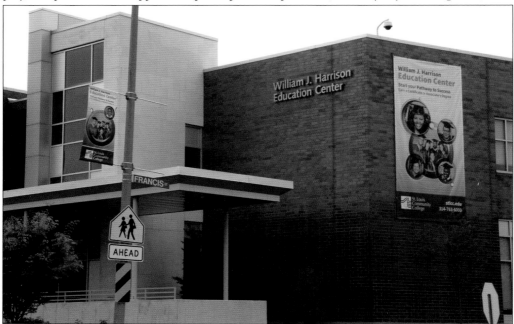

The William J. Harrison Education Center was named in honor of the late William J. Harrison, who played a major role in helping to establish this off-site learning center. Harrison had served as an associate dean of academic support and continuing education at St. Louis Community College–Forest Park. In addition to general education courses, the center offers associate degrees and certificates in four programs. (Courtesy of John Wright Jr.).

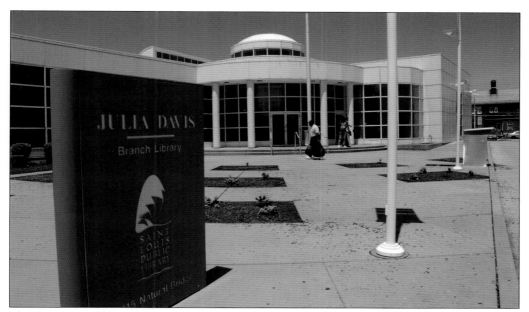

The St. Louis Public Library departed from tradition in 1974 when it named this branch for a living person. Julia Davis (1891–1993) was a well-known educator and historian. Davis taught in the St. Louis Public Schools from 1913 to 1963. At her retirement, she established the library's Julia Davis Fund for the purchase of books, manuscripts, and other materials related to African Americans. (Courtesy of John A. Wright.)

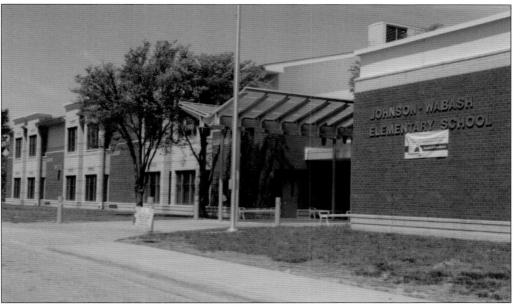

Pictured here is the Johnson-Wabash Elementary School. In 1924, the city of Kinloch became the first community in the state of Missouri to elect an African American, the Rev. Walter Johnson, to its local school board. After his election, Johnson became an outspoken vocal critic of the Kinloch district's refusal to build a high school for its African American students. (Courtesy of John Wright Sr.)

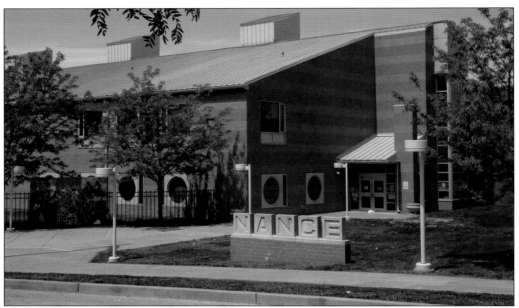

Earl Nance Sr. Elementary School opened in September 2002. The school is named after the former pastor of Mount Carmel Missionary Baptist Church. Reverend Nance was a former public school teacher and was very active with programs throughout the community, including those promoting positive involvement with young people and St. Louis Public Schools. (Courtesy of John Wright Jr.)

Attucks School, named after Crispus Attucks, in the Clayton School District, was a segregated school attended by African American students. The building accommodated students from kindergarten to the eighth grade and was open from 1923 to 1954. After the *Brown v Board of Education* decision, the school was closed. Pictured is a dedication to the building site and its students in 2007. (Courtesy of Donna Rogers-Beard and the Clayton School District.)

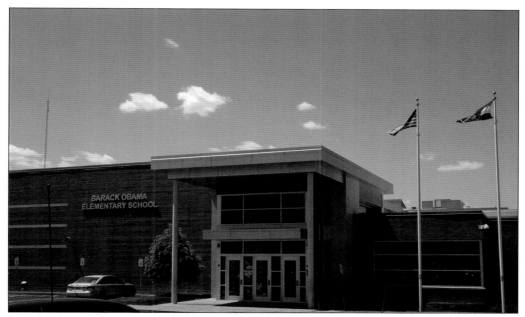

Barack Obama Elementary School is a part of the Normandy School District, located in Pine Lawn. The idea to name the school after the nation's 44th president was conceived by the student body. At the school's dedication on Sunday, August 7, 2011, district superintendent Stanton Lawrence said, "Barack Obama Elementary School represents the hopes and aspirations of the students who will go to school here." (Courtesy of John Wright Jr.)

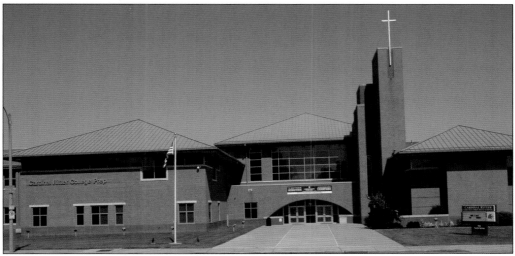

Cardinal Ritter College Preparatory High School was named after Cardinal Joseph E. Ritter (1892–1967), who ordered the desegregation of St. Louis archdiocesan Catholic schools in 1947. Established in 1979, the high school was recognized in 1984 as an exemplary institution by the US Department of Education. This predominantly black school has distinguished itself by consistently having more than 90 percent of its graduates go to college. (Courtesy of John Wright Jr.)

Vashon High School opened as an intermediate school in 1927, and four years later, became the city's second black high school. It is named for George Boyer Vashon, the first black graduate of Oberlin College, and his son John Boyer Vashon, a teacher and principal in the St. Louis Public Schools. In 2002, the school moved into this $47.3 million facility. (Courtesy of John A. Wright Sr.)

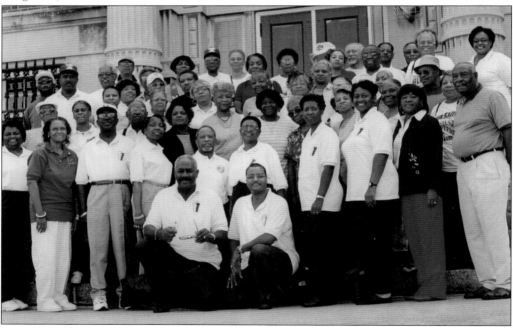

Pictured here are members of the Vashon Alumni Association. The organization is known for its active school involvement. Many credit the strong alumni for the construction of the new high school. Vashon has a long list of distinguish alumni, including Theodore McMillian, Elston Howard, Floyd Irons, Henry Armstrong, Maxine Waters, and Virgil Akins. (Courtesy of Vitilas "Veto" Reid.)

Sumner High School is the oldest high school for African Americans west of the Mississippi River. It was founded in 1875 and named for Charles Sumner, a US senator who, in 1861, became the first prominent politician to urge full emancipation. Sumner moved to this Georgian Revival building, designed by nationally acclaimed architect William B. Ittner in 1910. (Courtesy of John A. Wright Sr.)

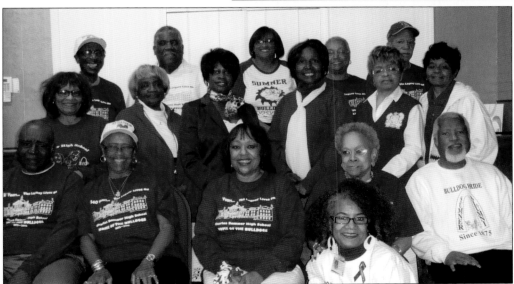

Sumner High has a very active alumni association and is reported to have the largest number of distinguished alumni in the country. The members of the alumni association pictured here planned the 140th anniversary of the school in 2015. Almost 900 people from all over the country attended the festivities. (Courtesy of Jacqueline Vanderford.)

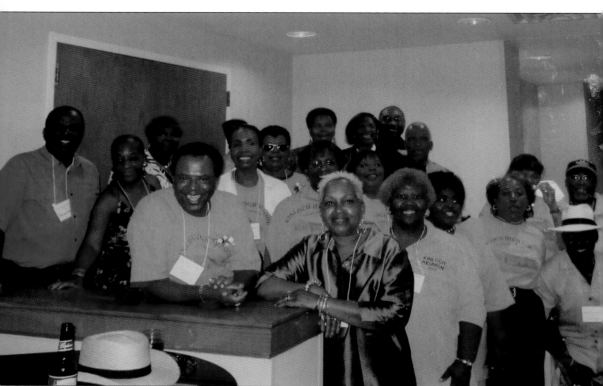

Douglass High school was the only school for black students until 1938, when Kinloch High School opened in the Kinloch School District. Prior to the opening of Douglass in 1925, all black students traveled to Sumner High School in St. Louis. Kinloch served only the black students in the Kinloch community. Douglass served all the black students in the 497 square mile of the county and beyond. Douglass closed in 1954 after the US Supreme Court decision calling for school desegregation. Kinloch remained open until 1975, when it was closed through a court ordered merger of the Kinloch School District with the Ferguson-Florissant School District. Although both schools have long been closed, they have active alumni associations. Pictured here are members of the Kinloch Alumni Association. (Courtesy of Dorothy Squires.)

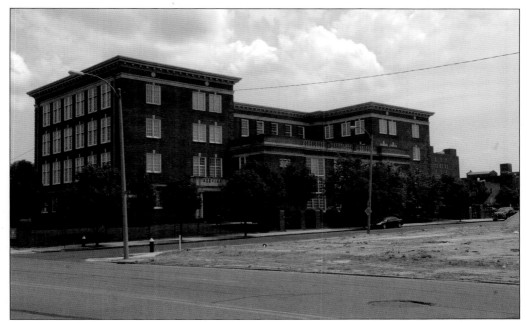

In September 1929, the first vocational school for African Americans in St. Louis opened, in Carr Lane Elementary School. In 1931, the school was relocated to the Franklin School (pictured). The following year, the school was named Booker T. Washington Technical High School. (Courtesy of John A. Wright Sr.)

Booker T. Washington Technical High School closed after the 1954 US Supreme Court decision regarding school desegregation. Members of the school's alumni association continue to meet each year on the eve of the school's graduation. Some of the graduates went on to college, some entered the labor force, and others joined the military. Shown here are members of the 1950 class at their 40th anniversary reunion. (Courtesy of Richard Scott.)

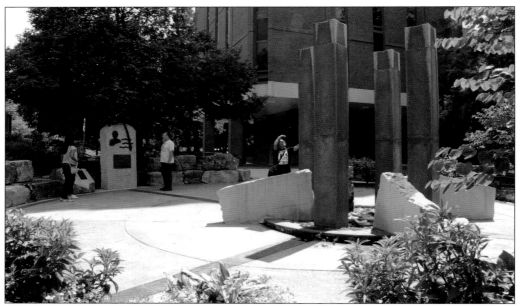

Marguerite Ross Barnet was the first African American chancellor of the University of Missouri–St. Louis. As leader, she achieved record-breaking fundraising for buildings and scholarships while simultaneously expanding academic programs. The plaza on campus named in her honor features four granite columns representing the four years (1986–1990) Barnett served as chancellor. Her sculpted likeness and plaque overlooks the plaza. (Courtesy of John Wright Sr.)

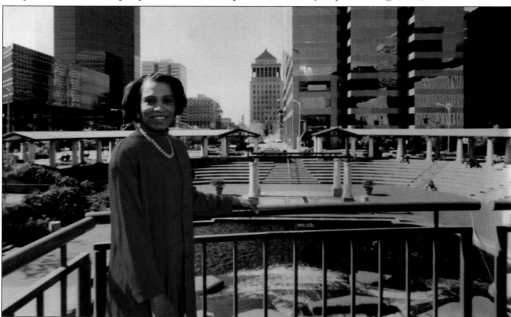

When Gwendolyn Stephenson took over the helm of St. Louis Community College in 1992 as chancellor, she became the first African American to head the institution. In her years as leader, she helped restore credibility and financial stability to the college. Before becoming chancellor, Stevenson served as president of Meramec Community College in St. Louis. (Courtesy of Pam Nichaus.)

In 1983, Kimberly Norwood became the first African American in the history of the University of Missouri School of Law to join the Missouri Law Review. In 1996, she became the first African American female to receive tenure at Washington University. In 2015, she again made history at Washington University, becoming the first African American female in the school's history to receive the Distinguished Faculty Award. (Courtesy of Kimberly Norwood.)

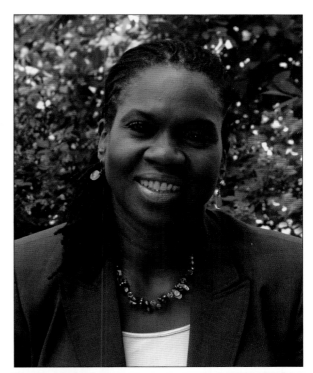

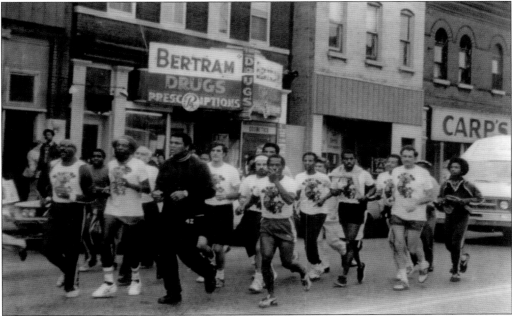

Muhammad Ali, Dick Gregory, Ronald Gregory, and Ivory Crockett, along with several others, are pictured on Manchester Avenue in 1976 running part of the St. Louis leg of the 3,000-mile run from California to New York to dramatize hunger in America. In 2013, the USDA reported that about 49 million Americans, one in six, are in danger of suffering from a lack of proper food. (Courtesy of Ronald Gregory.)

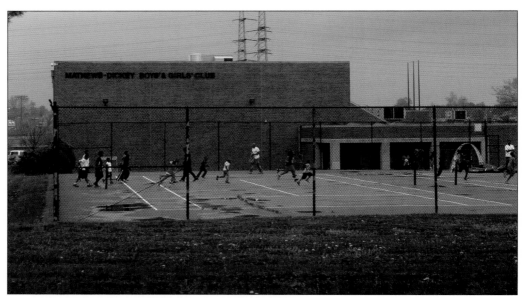

Each year, the Matthews-Dickey Boys' and Girls' Club serves some 40,000 youth ages 6 to 18 from throughout the St. Louis metropolitan area. The club began in 1961, when Martin L. Mathews and Hubert "Dickey" Ballentine began five neighborhood baseball teams, which played in Handy Park. A clubhouse soon opened in a storefront building. In 1981, the club dedicated its current $2.5 million facility. (Courtesy of John Wright Jr.)

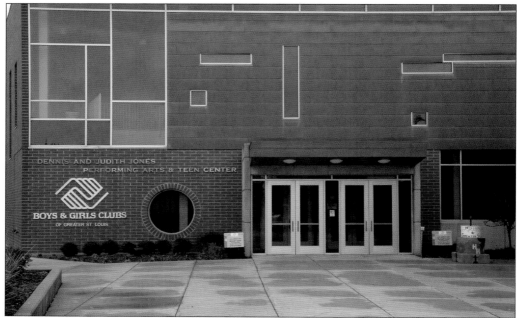

In 1967, the Herbert Hoover Boys Club was founded on the site of Sportsman's Park. In 2012, Herbert Hoover Boys & Girls Club became Boys & Girls Clubs of Greater St. Louis. This new name did not change the ongoing mission, dedicated to ensuring that the community's youngsters have greater access to quality programs and services that help to shape their futures. (Courtesy of John Wright Jr.)

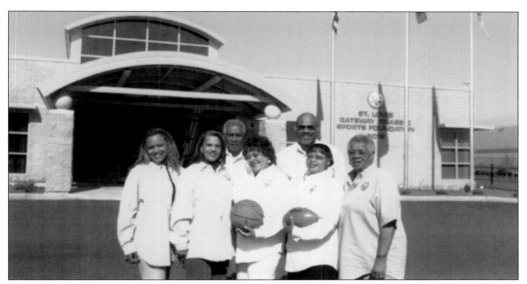

Earl Wilson (third from left), founder of the St. Louis Gateway Classic Sports Foundation, is pictured with his staff. Wilson established the foundation in 1984 with a mission to offer financial assistance to the community in the way of scholarships and sports programs. To date, the foundation has awarded nearly $3 million to students. The foundation supports its own African American Walk of Fame on the site's perimeter. (Courtesy of Earl Wilson.)

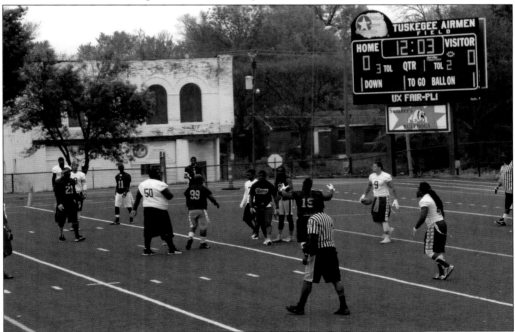

Tandy Park is named for Capt. Charlton H. Tandy, who led the movement to end segregation of public streetcars. Within the park is the Tandy Community Center, which, at its opening, had reading rooms, a swimming pool, a basketball court, a boxing ring, and an industrial arts space. The Arthur Ashe Tennis Courts and the Tuskegee Airmen Field are also pictured. (Courtesy of John Wright Jr.)

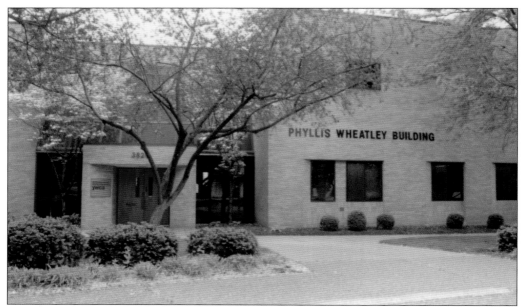

In 1911, women from the Union Memorial AME Church met to establish a branch of the YWCA for black girls. With the sanction of the St. Louis YWCA, the branch was established, then renamed in 1912 for Phyllis Wheatley (c. 1753–1784), an African-born poet and slave. It is presently located on the campus of St. Louis University at 3820 West Pine Avenue. (Courtesy of John Wright Sr.)

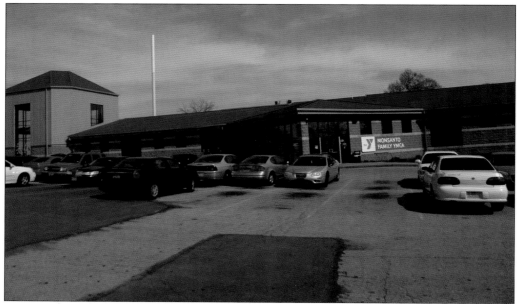

The Monsanto YMCA was built on the site of the former Page-Park Branch of the YMCA. This $2.5 million facility was financed in part by a $1.1 million gift from Monsanto. The auditorium at the facility is named for Dr. Arthur Vaughn, a prominent black St. Louis physician. It is also the home of the community track and park named for community builder Ida Woolfolk. (Courtesy of John Wright Jr.)

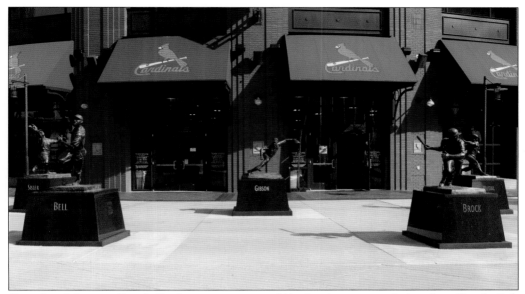

Outside of the new Busch Stadium are statues of Cardinals greats including Lou Brock, Bob Gibson, Ozzie Smith, and former St. Louis Stars (Negro Leagues) player James "Cool Papa" Bell. The statues stand at the corner of Clark and Eighth Streets, outside the team's store. (Courtesy of Curtis Wright Sr.)

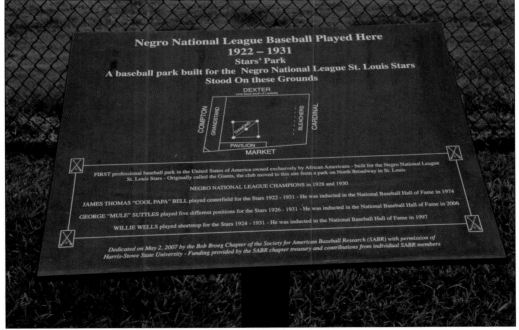

On the campus of Harris-Stowe State University is a plaque memorializing the historic baseball field that was once Stars' Park. This field was the first professional baseball park in America owned exclusively by African Americans. The park was constructed for the St. Louis Stars, a team in the Negro Leagues from 1922 to 1931. The team won championships in 1928 and 1930. (Courtesy of John Wright Sr.)

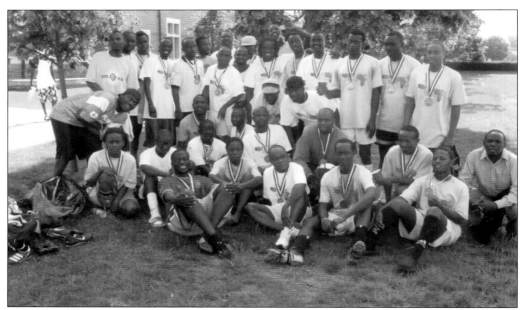

These are members of the two St. Louis African soccer teams. One team represented countries in east Africa, and the other team represented countries in the west. The game was played in 2005 at Washington University during the 15th Annual African Sister Cities Conference. The St. Louis Gateway Classic Sports Foundation provided medals for the event. (Courtesy of John A. Wright Sr.)

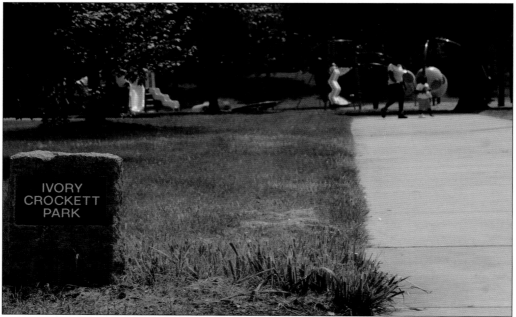

Ivory Crockett, a 1968 Webster High School graduate, was honored for outstanding athleticism with a park in his name by the city government of Webster Groves. In 1974, Crockett was declared the fastest human to run the 100-yard dash, with a record time of 9.0 seconds. On September 29, 1985, the city named the park after him. (Courtesy of John Wright Sr.)

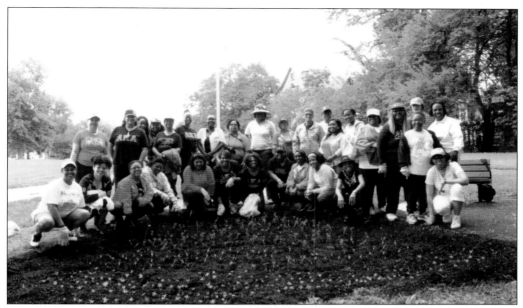

Here, the women of Alpha Kappa Alpha sorority beautify Ivory Perry Park. In March 1965, Perry laid down his body on a ramp at the intersection of Kingshighway Boulevard and Highway 40, stopping all oncoming traffic to protest in solidarity the violence against peaceful protestors in Alabama. Visitation Park, bounded by Clemmons Place, Belt Avenue, and Cabanne Avenue, was renamed in Perry's honor. (Courtesy of John Wright Sr.)

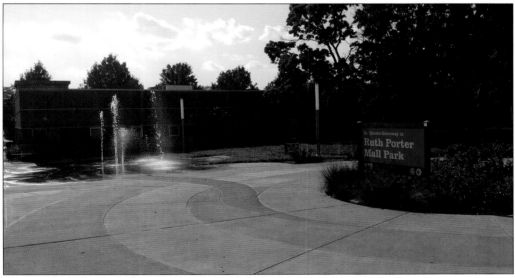

This mall honors Ruth C. Porter (1915–1967), one of the founders and the first executive director of the Greater St. Louis Committee for the Freedom of Residence, a group organized in 1961 to break down housing restrictions and integrate housing in St. Louis. She also formed Community Resources, a group working for school integration, and helped found Kinder Cottage, a church-supported preschool program. (Courtesy of Curtis Wright Sr.)

Greg Freeman Park, located in the Central West End, was named after an African American *Post-Dispatch* columnist who died in 2002 of heart failure. Freeman had a reputation for being a kind man of courage. His adulthood presented numerous health concerns, yet he was never known to have complained. The park serves as a playground for local children and neighborhood programs. (Courtesy of John A. Wright Sr.)

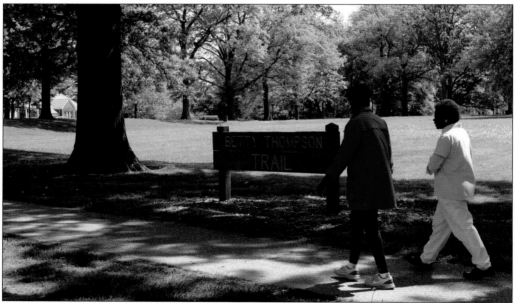

Betty Thompson was the first black woman elected to the University City Council, in 1980. In 2000, she served as Democratic majority whip while representing the 72nd District in the Missouri House of Representatives. She has won numerous awards for her leadership and commitment to civic progress. Thompson said she hopes the walking trail dedicated in her name will serve as an inspiration for others, especially the younger generations. (Courtesy of Curtis Wright Sr.)

Three

CULTURE AND SOCIETY

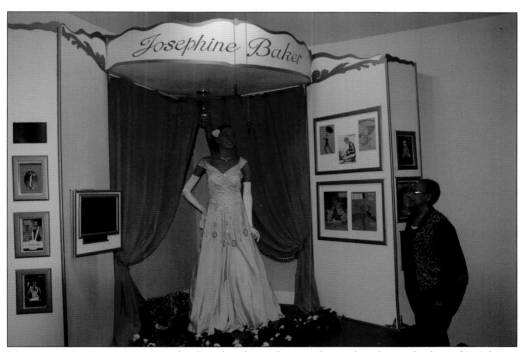

Museums, arts organizations, and cultural and social groups have played a vital role in the African American community, from the time of segregation to the present day. These institutions remind residents of the richness of the African American culture. Pictured here is Lois Conley, founder of the Griot Museum, where black history lives. (Courtesy of John A. Wright Sr.)

The Frederick Douglass Museum of African-American Vernacular Images, a private residential house museum located inside the historic Henry W. Peters House, was founded by Robert E. Green in 2013. The museum's mission is to narrate African American life as it was lived from the middle of the 19th century through the early part of the 20th century. The museum employs select photographs to counter negative images used in the depiction of black people. (Courtesy of John Wright Sr.)

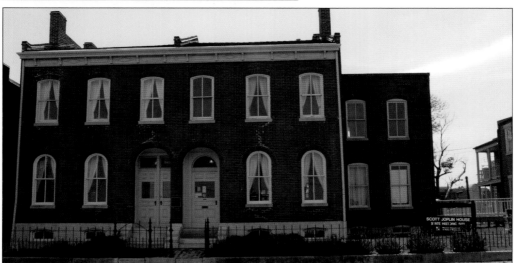

From 1901 to 1903, ragtime composer Scott Joplin and his wife lived in this four-family residence. The home was designated a national historic landmark in 1976 and opened to the public on October 6, 1991, after restoration. It now includes a room for musical performances as well as displays centering on Joplin's life and music (Courtesy of Curtis Wright Sr.)

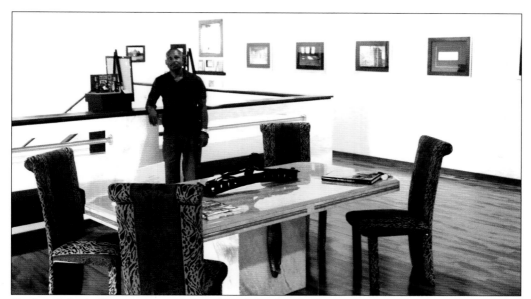

Carlton Mitchell is owner and founder of Exodus Galleries, an upscale venue for arts and entertainment. Exodus's mission is to be the premier gallery for arts and entertainment, promoting biblical principles and human achievement by edifying minds and elevating perspectives and ambitions, cultivating creativity and purpose, advocating the power of knowledge and artistic expression, and uniting and empowering individuals, families, and communities. (Courtesy of John Wright Jr.)

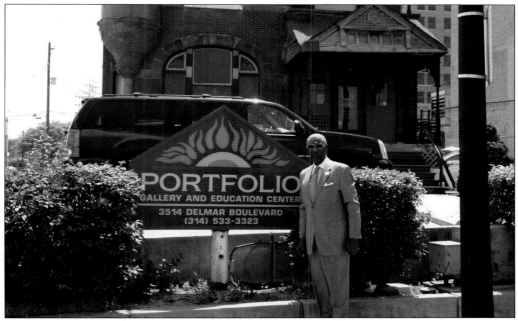

Portfolio Gallery and Educational Center was started in 1989 by its founder, Robert Powell. He is seen here outside the facility. Where once there was no black artistic presence in the city's historic arts district, Portfolio has become a haven for African American artistic expression in the St. Louis area. (Courtesy of John A. Wright Jr.)

The 10th Street Gallery is owned and operated by artist Solomon Thurman. The mission of the gallery is to promote, market, and exhibit the works of regional artists. The gallery's featured works include paintings, sculpture, and photography in a multicultural atmosphere. The function of the gallery is to assist emerging and seasoned collectors and artists, as well as the public, by offering lectures, talks, seminars, and community outreach. (Courtesy of Curtis Wright Sr.)

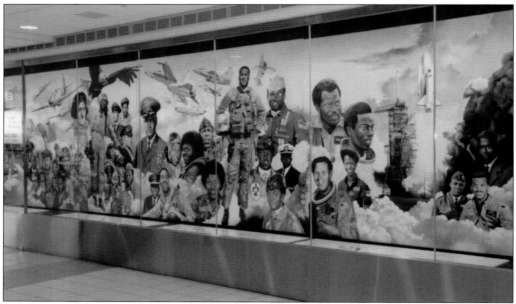

This 51-foot mural at Lambert International Airport, created by artists Spencer Taylor and Soloman Thurman, chronicles the achievements of blacks in aviation since 1917. The five-panel mural was created after a protest over the lack of any black fliers in a nearby mural by Siegfried Reinhardt depicting the history of aviation. This mural includes 75 portraits. (Courtesy of John A. Wright Sr.)

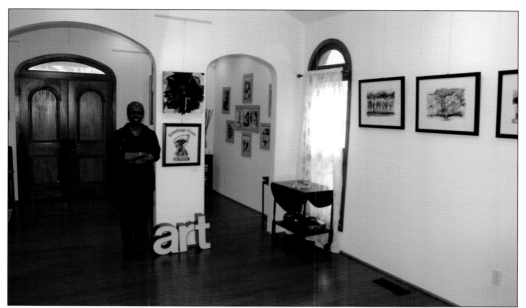

Maffitt Avenue Gallery Salon 53 (above) and the Vaughn Gallery (below) are curated by Freida L. Wheaton, pictured in both photographs. Salon 53 is a private residential art gallery housed in a 2006 addition to a 1917 residence. Its exhibitions change at least quarterly and often bimonthly and open with receptions, lunch, or brunch. The gallery has solo and group exhibitions as well as collaborations with artists and art institutions. The Vaughn Gallery is housed at the St. Louis Metropolitan Urban League headquarters at Grand Center. It was opened in 1979 with funds donated by Ermaline Vaughn in memory of her husband, Arthur Vaughn. The works of local and national artists are on display and are changed every two months. The gallery also provides a venue for local poets, musicians, and authors with published works. (Both, courtesy of John A. Wright Sr.)

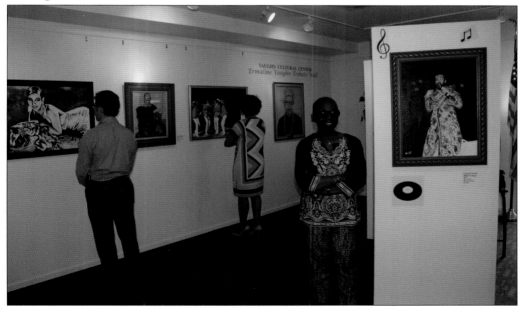

The George B. Vashon Research Center and Museum is the creation of Calvin Riley. He is a retired educator and lecturer on black memorabilia. After discovering the artifacts of George B. Vaughn (for whom Vashon High School was named), Riley was inspired to share his findings. He has assembled a collection of over 4,000 items, which are stored and exhibited in his museum. (Courtesy of John Wright Sr.)

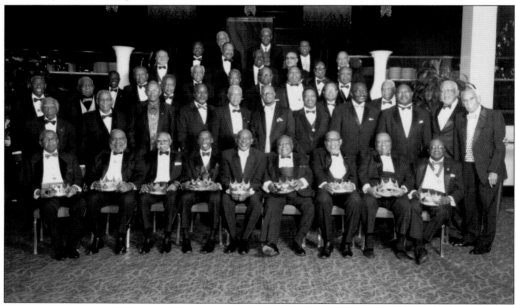

These men are members of The Royal Vagabonds, a nonprofit philanthropic organization organized over 85 years ago. A small group of black professionals and businessmen came together to plan, implement, and share common goals and activities to counter the limited social and intellectual opportunities for men of color. The organization's outreach program provides a variety of services throughout the community. (Courtesy of Joseph DuBose Jr.)

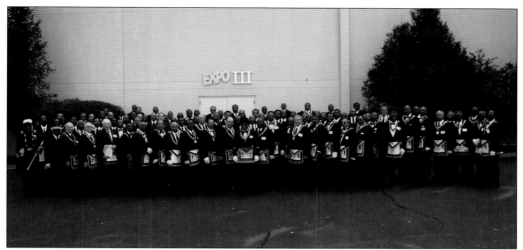

The men of Prince Hall Lodge of Masons have continued the proud tradition of service that began with the lodge's establishment in 1859. Historically, its members have taken a leading role in civic engagement. The early grand master, Moses Dickson, founded the Knights of Liberty, a secret origination formed in 1846 to wage a war against slavery. (Courtesy of Ronald Wilson.)

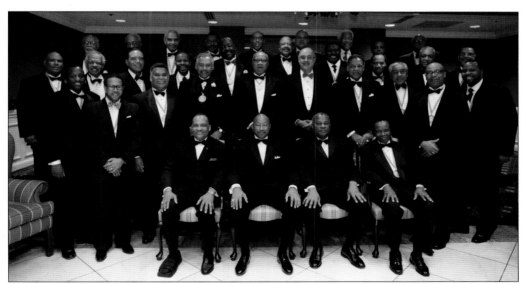

Sigma Pi Phi fraternity, known by many as the "Boule," is the oldest African American Greek fraternal organization in the country, founded in 1904 in Philadelphia. Its aim is to bring together men of like qualities, tastes, and attainment into a close, sacred union. The men pictured here, members of Eta Boule, represent a wide range of professions. (Courtesy of Richard White.)

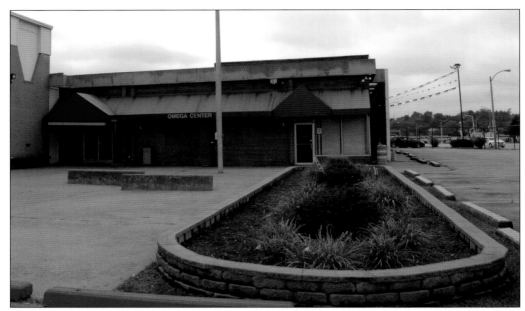

The Omega Center is the home of the Upsilon Omega chapter of the Omega Psi Phi fraternity. The center's 1,500-capacity hall and small room is the site of numerous community functions and Thursday-night bingo. It is also the home of the foundation's Annual Scholarship Luncheon. Each year, the fraternity awards thousands of dollars in scholarships to high school seniors. (Courtesy of John A. Wright Sr.)

Kappa Alpha Psi fraternity was established in 1911 at Indiana University and incorporated the same year. The St. Louis Alumni Chapter was chartered 10 years later, in 1921. The men of Kappa Alpha Psi offer a host of programs for young people, touching on leadership development and scholarship. The center is used by both members and the community for meetings and social events. (Courtesy of John A. Wright Sr.)

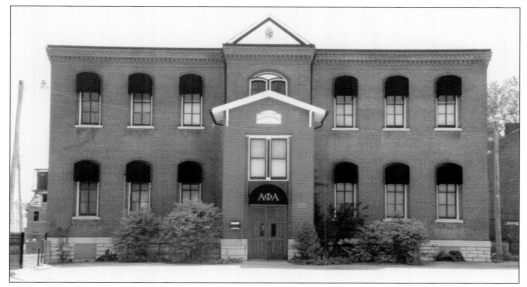

The members of Alpha Phi Alpha fraternity maintain a house in the city of St. Louis that has multiple functions. While it serves as a meeting place for the fraternity, the house is also a base of operations for many community outreach programs. These programs include preteen and teenage youth mentoring, back-to-school giveaways of school supplies, and the awarding of scholarships to deserving students. (Courtesy of John Wright Sr.)

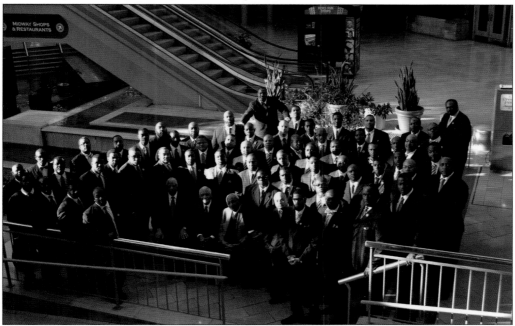

Phi Beta Sigma fraternity was founded on the campus of Howard University in Washington, DC, in 1914. The mission of its members is to promote brotherhood, scholarship, and service to humanity through designated programs and community outreach by developing and recruiting leaders. Phi Beta Sigma has two undergraduate chapters in St. Louis (Gamma Eta and Iota Kappa) and one graduate chapter (Kappa Sigma). (Courtesy of Robert Jordan.)

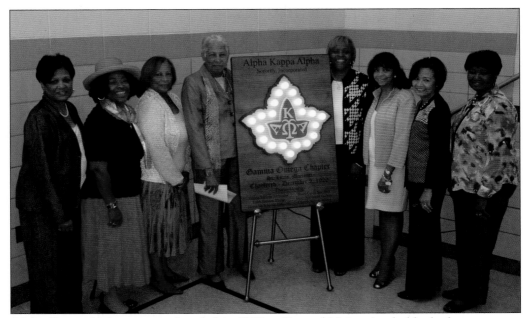

Alpha Kappa Alpha sorority, founded in 1908 at Howard University, holds the honor among black sororities as being the first established and incorporated. The ladies pictured here are former Basileus of the Gamma Omega chapter in St. Louis, founded in 1920. There are two other chapters in the city, Omicron Eta Omega and Omicron Theta Omega. (Courtesy of Teri Bascom.)

Delta Sigma Theta sorority has one undergraduate chapter and two graduate chapters. The St. Louis Alumnae Chapter of the sorority was chartered in 1926 and is the home of civil rights attorney Frankie Muse Freeman, the 14th national president of Delta. The sorority is dedicated to making significant positive impacts on the community through its activities, workshops, and programs in the St. Louis area. (Courtesy of John Wright Jr.)

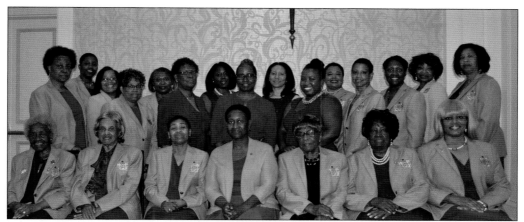

Sigma Gamma Rho sorority takes pride in being a leading national service organization that strives to meet daily goals of sisterhood, scholarship, and extraordinary service to the community at large. The St. Louis Zeta Sigma chapter of the sorority has the distinction of being the third graduate chapter in the sorority's history to have three national presidents. (Courtesy of Dorothy Smith Turner.)

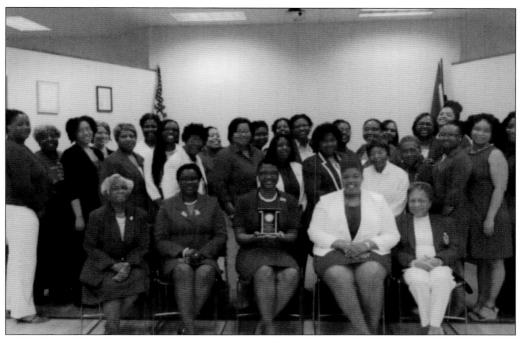

Zeta Phi Beta's Xi Zeta chapter was awarded the Midwestern Region 2015 Chapter of the Year award, and is recognized as one of the premier service organizations in St. Louis. The mission of Xi Zeta chapter is to focus on the sorority's principles by building on traditions from the past and transforming the future through programs designed to enrich the mind, body, and spirit. (Courtesy of Barbara Cunningham.)

For entertainment and socialization, the men and women of the Ville neighborhood formed clubs. One of the oldest of these St. Louis circles is the Booklovers Club, founded in 1907. In 1912, the group reached 25 members. It was thought that a group any larger would be too big for meetings in their living rooms. Pictured here are the women of the present Booklovers Club. (Courtesy of Rosalind Early.)

Carolyn Blair and Shawn Spence, who met at a gas station in South City, founded the Jambalaya Book Club in 2000. After a second random meeting at the home of Kimberly Norwood, a Washington University law professor, the book club was born. There are approximately 26 ladies in the group from around the country. Here, members gather at a sisterhood event at a Missouri winery. (Courtesy of Kimberly Norwood.)

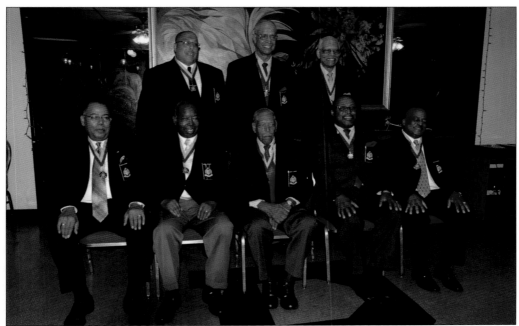

Shown here are some of the men of the Prometheans (also known as Men of Fire). The organization was formed in 1960 for the purpose of creating civic and social activities. The club's name comes from Prometheus, who, according to Greek mythology, stole fire from the sun and gave it to mortals. Today, the club is recognized for its work for community betterment. (Courtesy of John A. Wright Sr.)

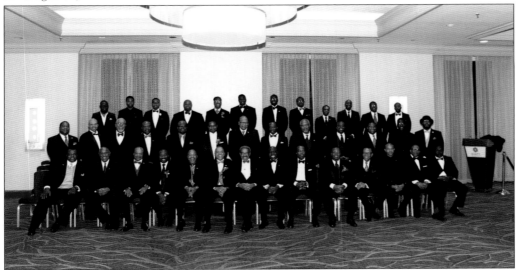

100 Black Men of Metropolitan St. Louis is a nonprofit, community-based organization whose mission is to improve the quality of life in the community and enhance educational and economic opportunities for all. Its membership (pictured) consists of entrepreneurs, business executives, educators, clergy, attorneys, and politicians. In 2015, the group received its national organization's highest award, the Wimberly Award, for outstanding community service. (Courtesy of Arthur Perry.)

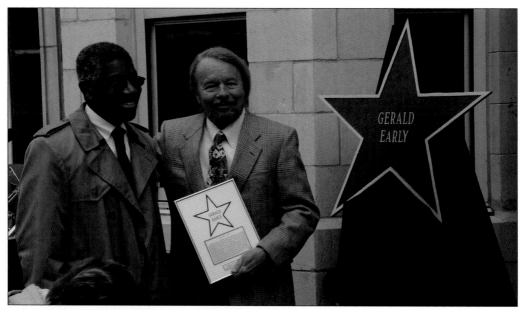

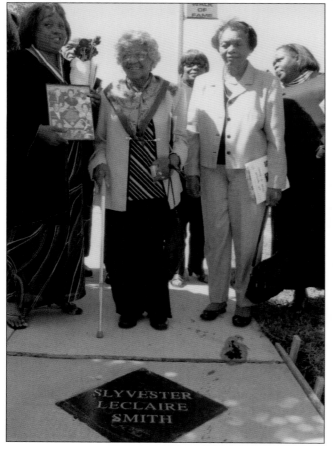

The St. Louis Walk of Fame can be found in the Delmar Loop of University City. This project, founded by businessman Joe Edwards, began in 1988 to commemorate famous St. Louisans with bronze stars and plaques set in the Delmar sidewalks. Each year, 10 new names are chosen. Among those names are several prominent African Americans. Here, Dr. Gerald Early (left) poses with Edwards at Early's star dedication. (Courtesy of John Wright Sr.)

The Black Walk of Fame was established by the St. Louis Gateway Classic Sports Foundation to honor the accomplishments of St. Louis African Americans. Pictured in front of this diamond on the walk honoring educator Sylvester Smith is his daughter, Beverly Davison (left), along with two of his former students. (Courtesy of John A. Wright Sr.)

On June 8, 2012, the Dred Scott Heritage Foundation, the National Park Service, and master sculptor Harry Weber unveiled this statue of Dred and Harriet Scott in front of the Old Courthouse. The street passing in front of the courthouse has been renamed Dred Scott Way. The Scotts are depicted holding their heads high, their eyes directed across the Mississippi River toward a horizon of freedom they hoped they would see. (Courtesy of Curtis Wright Sr.)

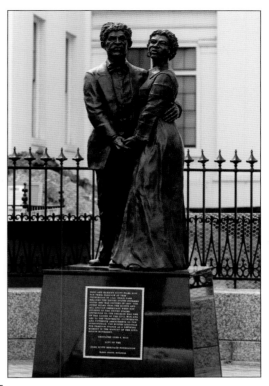

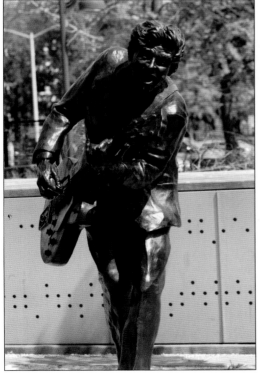

This statue of Chuck Berry immortalizes the rock 'n' roll icon doing his famous duck walk while playing his big electric guitar. The eight-foot bronze statue stands on the St. Louis Walk of Fame, across the street from Blueberry Hill, where a great deal of Berry memorabilia is on display. Berry was inducted into the Rock and Roll Hall of Fame in 1986. (Courtesy of Curtis Wright Sr.)

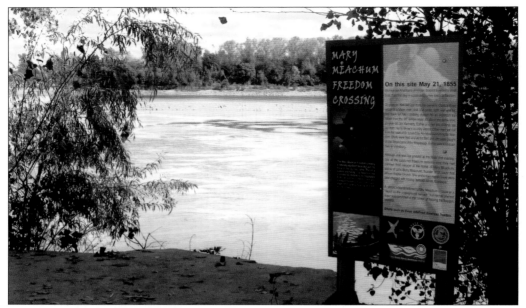

On November 1, 2001, Mary Meachum Freedom Crossing became the first site in Missouri to be accepted in the National Underground Railroad Network to Freedom. Located on the banks of the Mississippi River, the site can be found 500 yards north of the Merchants Bridge. On this site, courageous African Americans boarded a small boat to escape to freedom on May 21, 1855. (Courtesy of John A. Wright Sr.)

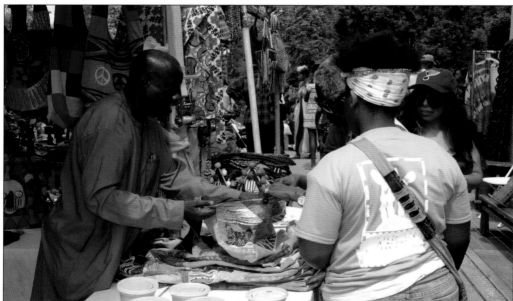

The St. Louis African Arts Festival is held each Memorial Day weekend in Forest Park. The idea stemmed from academic, business, and community leaders wanting to provide a forum that would bring Saint Louisans together for the purpose of learning and celebrating the cultures of African and African American peoples. The festival draws a diverse crowd of thousands. (Courtesy of John Wright Sr.)

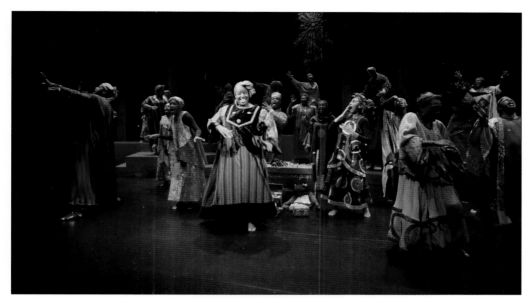

In 1976, producing director Ron Himes founded The Black Rep, the largest professional black theater company in the nation. It is also the largest African American performing-arts organization in Missouri. Today, The Black Rep produces dramas, comedies, and musicals, mainly from African American and third-world playwrights. Its main stage productions and educational programs combine to reach more than 80,000 people annually. (Courtesy of The Black Rep.)

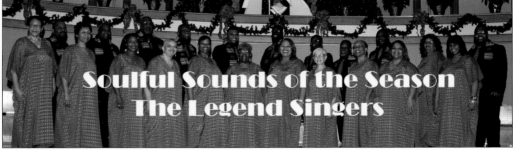

The late Dr. Kenneth Brown Billups established the Legend Singers in 1940. The singers' mission is to preserve and perform the musical practices of African Americans and of composers who were influenced by African American musical forms. Under the direction of Dr. Doris Jones Wilson, this group develops outreach programs to continue traditions of excellence in artistic performance of African American choral music. (Courtesy of the Legend Singers.)

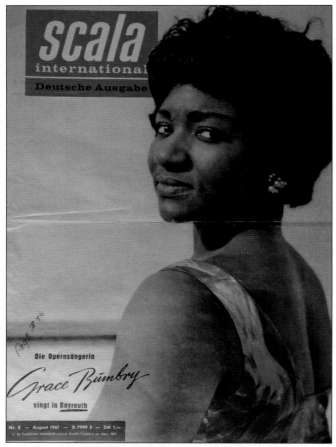

The 1960s marked the beginning of the opening of many doors for African Americans in white venues. In 1961, Grace Bumbry (left) became an international opera singer and the first African American singer to perform at the Bayreuth Festival in Germany. Albert King became the first blues musician to perform in concert with a symphony orchestra when he performed at Powell Hall. In 1960, Clark Terry became the first African American on the payroll at the National Broadcasting Company. Because of these pioneers and other black entertainers, groups like Dirty Muggs (below), founded by Dee Dee "Muggs" James, can be found playing throughout the Midwest in nightclubs, festivals, and corporate parties. (Left, courtesy of John Wright Sr.; below, courtesy of Gary James.)

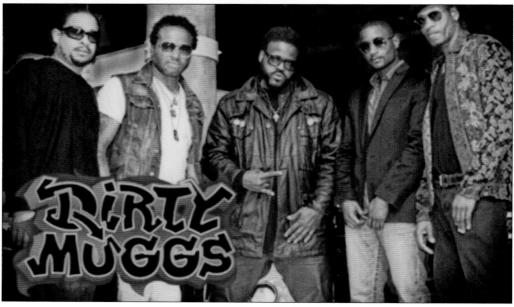

Four

GOVERNMENT AND BUSINESS

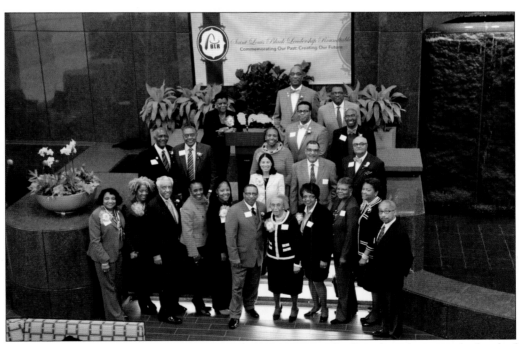

Today, members of the African American community can be found at almost every level of area government and leadership, and serving as operators and owners of a variety of business establishments. Pictured here are members of the Black Leadership Roundtable. They are some of the most influential African Americans in St. Louis, representing almost every segment of the community. (Courtesy of the Black Leadership Roundtable.)

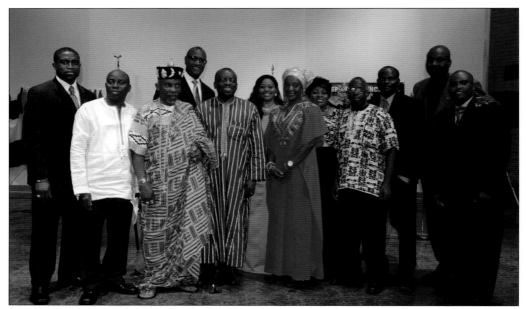

The African Diaspora Council of St. Louis, a public institution, was established in 2014 to mobilize anyone with African heritage in the diaspora into a united body. The social betterment institution offers guidance and service in the fields of education, finance, and advocacy. Pictured here is the executive committee, which guides the organization, along with a few guests. (Courtesy of John A. Wright Sr.)

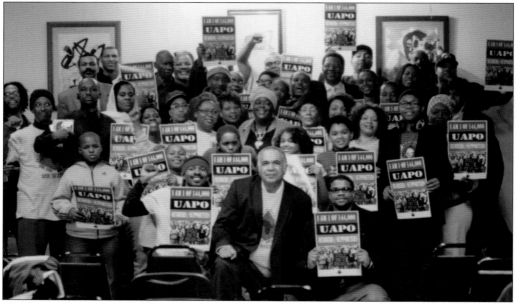

These young people are members of the Universal African Peoples Organization. In the center is cofounder and president Zaki Baruti, who established the organization in 1989. Its vision is to build an influential movement of likeminded people who support the group's motto: "One God—One Goal—One Destiny." The organization holds annual programs celebrating the life of prominent African American leaders. (Courtesy of Zaki Baruti.)

In 1993, Freeman Bosley Jr. became St. Louis's first African American mayor in its 229-year history, winning with 67 percent of the vote. Prior to being elected mayor, he was elected clerk of the circuit court of St. Louis in 1982. This office had 200 employees and an annual budget of over $40 million. (Courtesy of *Newsgram*, City of St. Louis.)

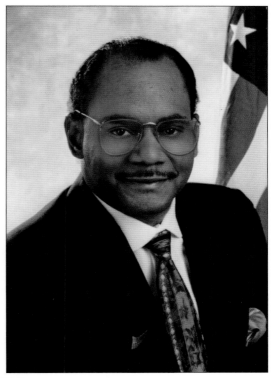

Clarence Harmon became the city's second African American mayor in 1997. When he was appointed secretary of the St. Louis Police Board, he became the first black in that position in the 129-year history of the police department. The following year, he was appointed the city's first black police chief, in a department where he had served for 21 years. (Courtesy of *Newsgram*, City of St. Louis.)

In 1991, Sherman George became the city's first black fire chief. George had a distinguished career with the fire department. While the youngest captain in the department, he became the city's first black chief instructor of the fire academy since its inception in 1857. George was in charge of all training programs for the entire fire department and new recruits. (Courtesy of *Newsgram*, City of St. Louis.)

Darlene Green, comptroller of the City of St. Louis, is the first woman to serve in that position. She directs all the fiscal affairs of the city, which has a combined annual budget of more than $900 million. Under Green's leadership, in 2008, the city was upgraded to an A+ credit rating for the first time in 35 years. (Courtesy of Darlene Green.)

In 2007, Lewis E. Reed became the first black to be elected president of the board of aldermen for the City of St. Louis. Prior to coming to office, Reed became the first black elected to serve as alderman of the city's Sixth Ward. In 2014, he became the first area politician to be accepted to the Local Leaders Council of Smart Growth America. (Courtesy of Lewis Reed.)

Mavis Theasa Thompson has made history twice: as the first African American to serves as circuit clerk for the City of St. Louis, and as license collector for the city. She was first appointed by the governor in 2013 and elected to the position the following year. Thompson has served as the president of the National Bar Association, leading attorneys and judges worldwide. (Courtesy of Mavis Thompson.)

Tishaura O. Jones was sworn in as treasurer of the City of St. Louis in 2012, becoming the first woman to hold that office. As treasurer, Jones is the chief investment and management officer of the city. Prior to becoming treasurer, she established a track record of leadership in the Missouri House of Representatives, as the first African American woman to serve as minority whip. (Courtesy of Tishaura Jones.)

Charlie Dooley was appointed St. Louis County executive in 2003, and went on to be elected to the office in 2004 and re-elected in 2006 and 2010. As county executive, he managed a county of a million people and a budget in excess of $500 million. Prior to assuming office, Dooley served in a variety of civic positions. (Courtesy of the World Trade Center of St. Louis.)

Hazel Erby, councilwoman for the 1st District in St. Louis County, is the first African American woman and the second African American elected to the position. Erby has been an outspoken defender of human rights and fairness in the awarding of contracts and jobs for her district. She is the recipient of numerous awards for her work in the community. (Courtesy of Hazel Erby.)

The Mound City Bar Association is one of the oldest African American bar associations west of the Mississippi River. This organization strives to provide community service, promote professional development that will advance the careers and interests of its members, and uphold the honor of the legal profession. Here, some of the association's African American judges gather at an event to provide scholarships to deserving students. (Courtesy of John Wright Jr.)

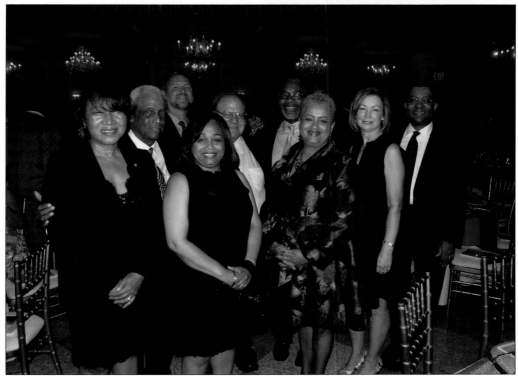

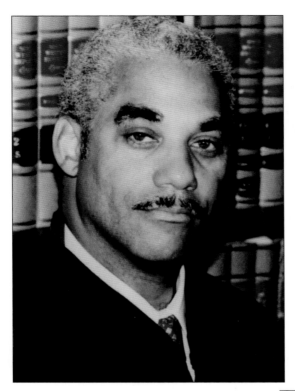

George Draper III became the second African American to serve on the Missouri Supreme Court when he was appointed in 2011. Prior to his appointment, Draper served in a variety of legal positions. He also served as the first African American chief judge of the Missouri Court of Appeals, Eastern Division. (Courtesy of Judy Draper.)

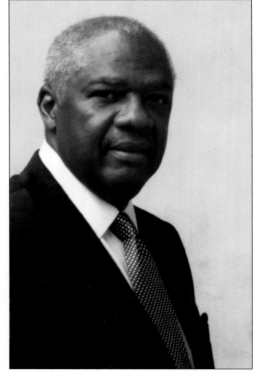

Ronnie White made history when he became Missouri's first African American state supreme court judge in 1995. After graduation, White began his political career as an intern in the Jackson County prosecutor's office and as a legal assistant in the US Department of Defense Mapping Agency. Prior to his appointment to the supreme court, White served as a judge for the court of appeals. (Courtesy of John A. Wright Sr.)

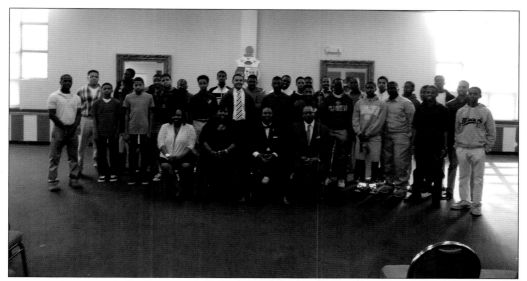

Mound City Medical Association is the voice of minority physicians and health professionals. The Mound City Medical Forum was chartered in 1920 as the first local component society of the National Medical Association established west of the Mississippi. Mound City's mission is to promote science, the art of medicine, and the betterment of public health. Here, Mound City officers gather at a Kappa League health symposium. (Courtesy of Kenneth Poole.)

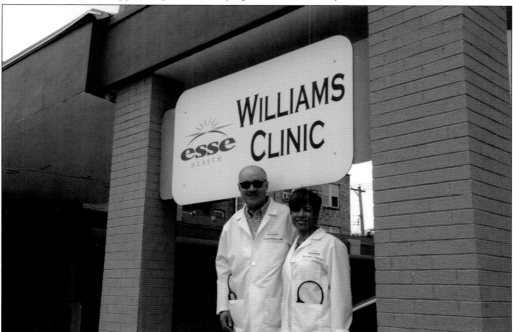

Williams Clinic can trace its roots to the early 1960s, when Roy Jerome Williams Sr. opened its doors. Williams was following in the footsteps of his father, who began to practice medicine in St. Louis in 1921. The clinic is now operated by Roy's son Roy Jerome Jr. and his wife, nurse practitioner Marva Williams (pictured). Together, they continue the legacy. (Courtesy of John A. Wright Sr.)

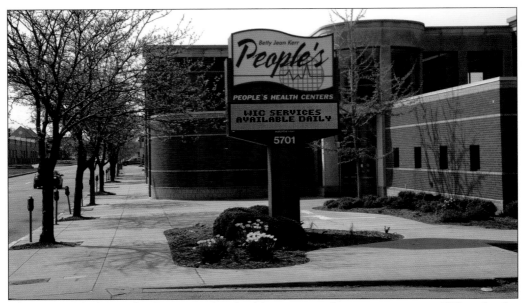

People's Health Centers has been providing health services to the community since 1972 and today operates out of three locations: St. Louis, Florissant, and Maplewood. The mission of the institution is to provide comprehensive primary health care, such as pediatrics, internal medicine, OBGYN, dental, mammography, behavioral health, and pharmacy. (Courtesy of John A. Wright Jr.)

Here, some of the children involved with the Community Health Festival at CHIPS Health and Wellness Center pose with founder and president Judy Bentley (center). CHIPS was founded in 1990 as a nurse-managed clinic to provide health care and social services to low-income, underserved, and uninsured residents in the area. Today, CHIPS provides over 50,000 service encounters a year. (Courtesy of Judy Bentley and CHIPS.)

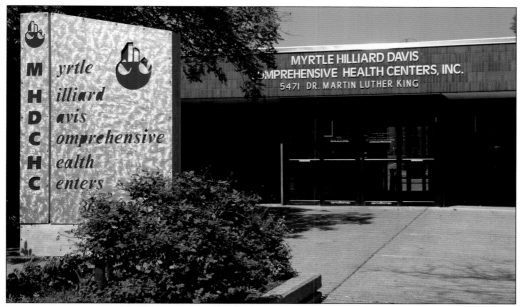

Myrtle Hilliard Davis Comprehensive Health Centers was founded in 1969 with a mission to provide comprehensive services in the form of health care, education, and support to all who need it, regardless of their personal circumstances. With a focus on health services, Comprehensive seeks to eliminate health disparities and empower all within the community with the tools necessary for a long, healthy life. (Courtesy of John Wright Jr.)

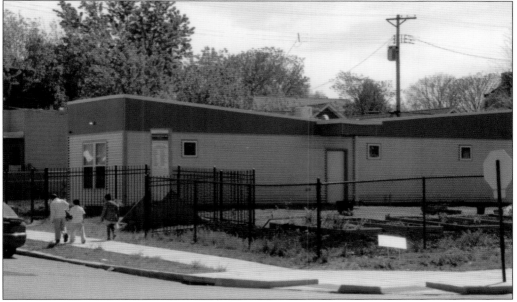

This new butterfly house on the corner of Sherdon and Garrison Avenues is a tribute to Lillie V. Pearson, who operated a confectionery on this spot from 1948 to 1988. The effort to keep her memory alive is driven by her granddaughter Carla Anderson, with the support of her husband, Miguel. Carla's goal is to build a library, research center for children, and community garden. (Courtesy of John A. Wright Sr.)

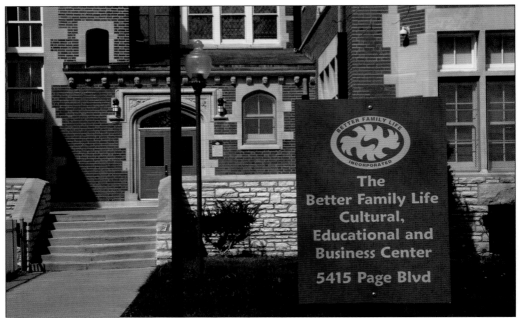

Better Family Life (BFL) is a nonprofit agency established in 1983. Its mission is to assist African American families confronting societal challenges by providing assistance through an array of programs directed toward strengthening and preserving the family unit. BFL, headquartered in the historic Emerson School, serves more than 50,000 customers annually. (Courtesy of John Wright Jr.)

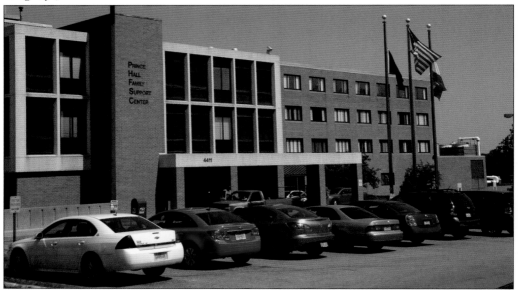

The Prince Hall Family Support Center is home to numerous programs put in place to help the community build and maintain families. Volunteers meet at the center for mentoring programs, which help with job training and job readiness. The center offers a safe place for young children and functions as a heating and cooling center for those needing shelter from the weather. (Courtesy of John Wright Sr.)

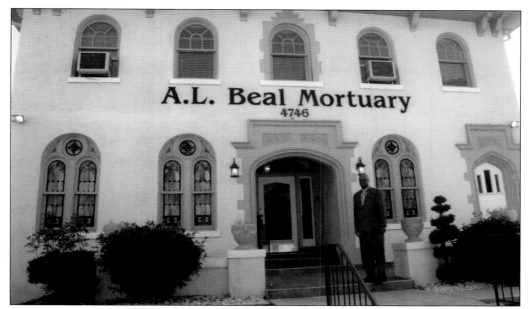

A.L. Beal Undertaking Company, the oldest operating African American business in Missouri, was established in 1913 by Albert Lee Beal. After his death, his daughter Birdie Beal T. Anderson became president of the company. She was the first black female licensed embalmer in Missouri and one of the organizers of the Missouri-Kansas State Morticians Association. (Courtesy of John A. Wright Sr.)

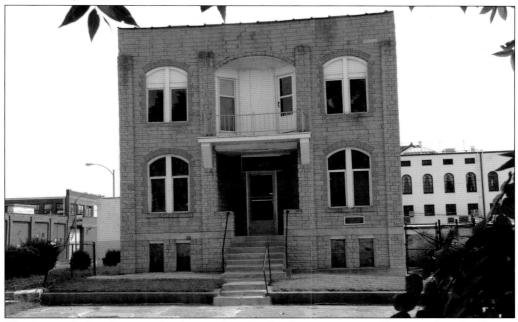

The Casper Casket Company has been in business for close to a century. Company founder George Carper had a vision to start the Funeral Directors Casket Company to service local funeral homes. It was the only black-owned casket company in Missouri. It stopped making caskets in 1948 and is now only a casket distributor. (Courtesy of John A. Wright Sr.)

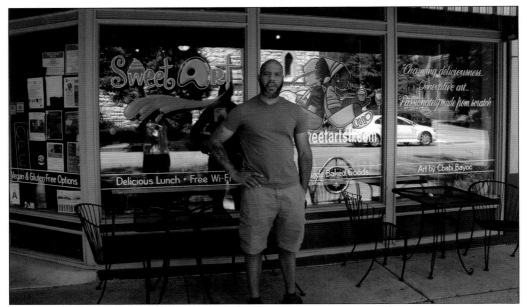

Sweet Art is a family-owned bakery, café, and art studio. This business is committed to serving excellent vegan food and providing community service while offering an atmosphere of family-friendly artistic expression. Baker and co-owner Reine Bayoc, who studied in Lyon, France, is responsible for the delicious vegetarian items. Her husband and co-owner, Cbabi Bayoc (pictured), is a renowned artist and children's-book illustrator. (Courtesy of John Wright Jr.)

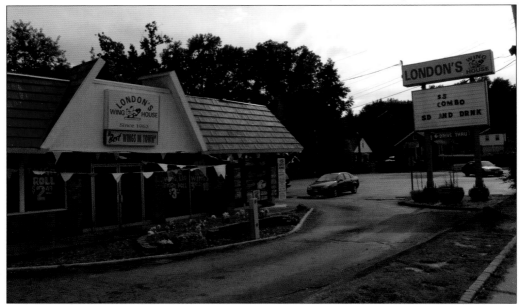

London's Wing House, formerly London & Sons Wing House, has been a family-owned community business for more than 50 years. Its business concept has been adopted by many chicken wing chain restaurants. The unique styles and flavors of the food have made this restaurant famous throughout the region and generated widespread patronage from all around the St. Louis area. (Courtesy of John Wright Sr.)

Robbie Montgomery was a former "Ikette"—a backup singer with Ike and Tina Turner. She also sang with many other artists. After retiring from singing, Montgomery took to another passion: cooking. With her son Tim Norman, she opened Sweetie Pie's. The flagship restaurant, Sweetie Pie's Upper Crust, is prominently featured in the OWN network reality program *Welcome to Sweetie Pie's*. (Courtesy of Curtis Wright Sr.)

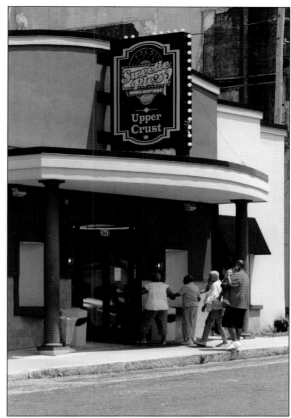

Darryl T. Jones is president of TRI-TEC, a food-service management firm. The company operates the food services at Lambert International Airport, where access to quality food is provided to over seven million passengers annually. Jones, partnering with other companies, also oversees food service at Scottrade Center and America's Center. (Courtesy of John A. Wright Sr.)

The *St. Louis American* is the largest weekly newspaper in Missouri, printing over 70,000 copies weekly. It is distributed to 84 locations in St. Louis, St. Louis County, St. Charles, and portions of Illinois. For six of the past eleven years, the *American* has been rated the best African American newspaper in the nation. The paper is also the recipient of several Russwurm Awards. (Courtesy of John A. Wright Sr.)

The *Black Pages* is the largest-circulation publication in America targeting African Americans. The publication is free, and one of its 199,000 copies can be found in over 500 locations. African Americans make up one third of the population in St. Louis city and county and spend $4.85 billion each year. For those wishing to reach the black community, the *Black Pages* provides that avenue. (Courtesy of John A. Wright Sr.)

David Steward cofounded World Wide Technology in 1990. It provides technology products, services, and supply-chain solutions to customers around the globe. From humble beginnings, the firm has grown into one of the largest black-owned companies in the United States, with more than $4 billion in annual revenue and 1,800 employees. (Courtesy of Curtis Wright Sr.)

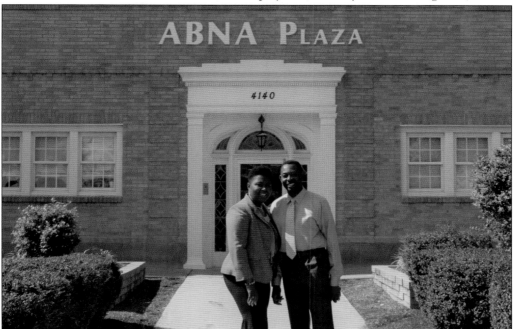

Abe and Nicole Adewale formed ABNA Engineering in 1994, and the company has grown to over 70 employees with offices in St. Louis, Chicago, and Southern Illinois. ABNA provides structural and civil engineering design services for civic facilities and public utilities. As community leaders, the Adewales are regional sponsors of the FIRST Robotics competition and the National Society of Black Engineers' scholarship fund. (Courtesy of Curtis Wright Sr.)

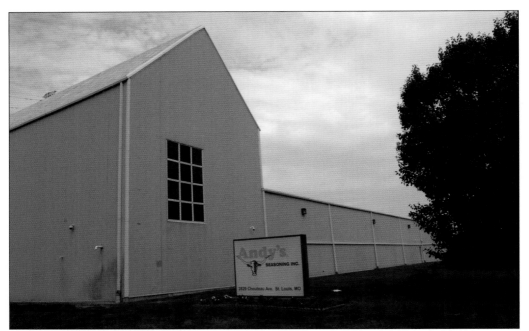

Andy's began in the basement of Reuben "Andy" and Katherine Anderson's home. In 1983, Andy's moved from the basement to a rented facility at 1931 Washington Avenue, and then again to its present location at 2829 Chouteau Avenue. By 2006, Andy's had become a multimillion-dollar enterprise and the facility had doubled in size. The Anderson couple's son Larry Lee now runs the company. (Courtesy of John A. Wright Sr.)

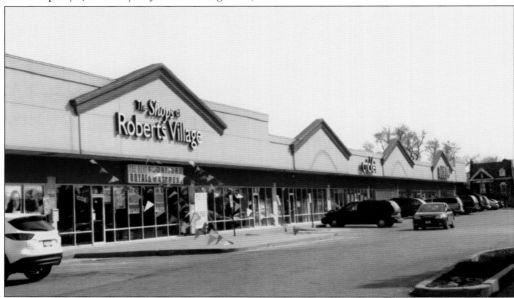

Roberts Village is just one of the many holdings of Michael and Steve Roberts. They became the first African American telecommunications and media owners in St. Louis, building a business empire that includes television, radio broadcasting, real-estate development, and hotel management. (Courtesy of John A. Wright Sr.)

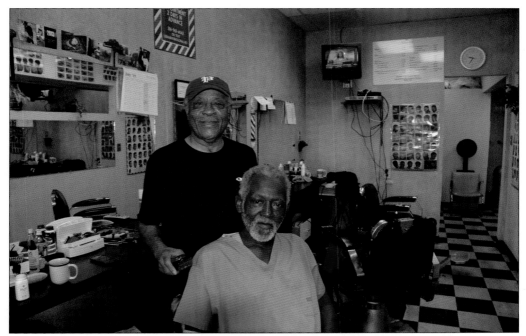

The Lee Moss Barber Shop is a longtime fixture in North Webster and St. Louis County. The owner, Lee Moss (standing), opened the shop in 1967. Since that time, it has been the place for customers from every walk of life. Moss has expanded his business to include a hair salon. He believes in giving back and serves on many community committees. (Courtesy of John A. Wright Sr.)

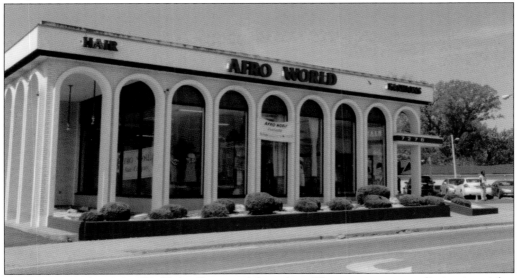

Its owner considers Afro World the "keeper of the culture," because it serves a distinctive niche. Russie B. Little Sr. founded the company in 1969 as a mail-order human hair business. Today, under the leadership of his daughter Sheila Little-Forrest, the company has grown into Afro World Hair & Fashions and has become synonymous with Afrocentric clothing. (Courtesy of John A. Wright Sr.)

Donnell Reid, the only African American bank board president in Missouri, is affiliated with Bank Star, a privately owned, $300 million financial holding company. Reid is the former president and CEO of Gateway National Bank, Missouri's only bank that was owned and operated by African Americans. During his three-year tenure at the bank, it grew from $25 million to $45 million in value. (Courtesy of Donnell Reid.)

Since Stuart Electric was founded in 1938, three generations of the Stuart family have worked in the electrical industry. The firm later became Centrex Electrical Supply. While remaining family owned, the company services a 200-mile radius of the St. Louis area. Centrex has won numerous awards, including being named one of the top 2013 Minority Business Enterprise companies in the St. Louis area. (Courtesy of Curtis Wright Sr.)

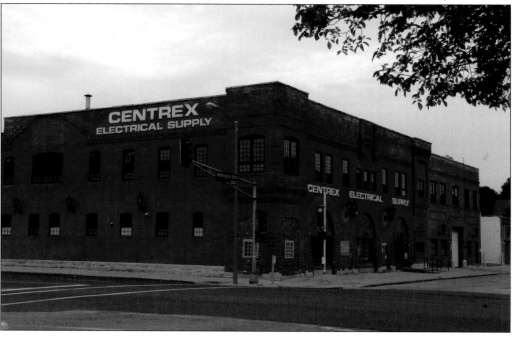

In 1994, Mayor Freeman Bosley Jr. of St. Louis and Mayor Abdoulaye Chimere Diaw of Saint-Louis, Senegal, came together to sign a sister-cities agreement. This was a sign to the community that race should not be used as a means for division. Pictured here are committee members from both cities after the signing. (Courtesy of John A. Wright Sr.)

In 2001, the Missouri Botanical Gardens featured 66 stone pieces from the Chapungu Sculpture Park in Zimbabwe. The garden acquired two pieces, which remain on display. Pictured is one of the two pieces, *Sole Provider*, by Joe Mutasa. It was dedicated to the people of the United States from the people of Zimbabwe in memory of those who perished on September 11, 2001. (Courtesy of John Wright Jr.)

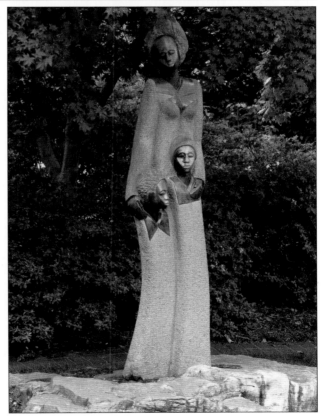

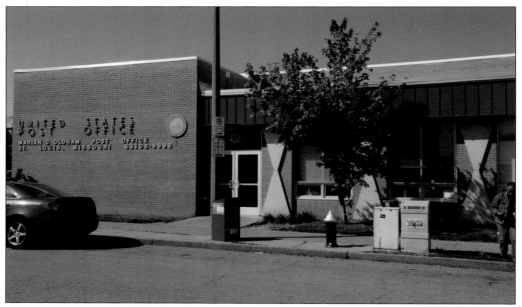

The Marion O. Oldham Post Office, formerly Laclede Post Office, was renamed for Marian Oldham, the first black woman on the University of Missouri Board of Curators. Her role at the school was of interest, as she was once denied admission as a student because of her race. Oldham made news in 1963 when she was jailed for protesting against the racially discriminatory hiring policies of Jefferson Bank. (Courtesy of John Wright Sr.)

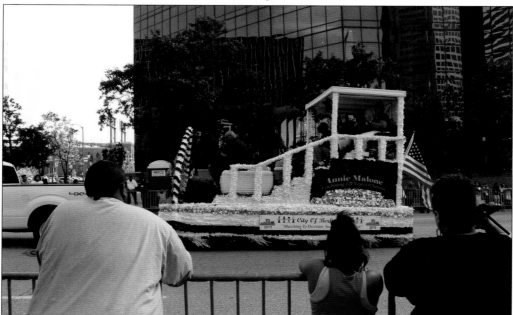

The Annie Malone Children's Home was named for millionaire philanthropist Annie Malone. She took a strong interest in the home and became a sponsor of this agency. In 1919, Malone took over as board chairman, a position she held until 1943. In 1920, she donated money to build the home. An annual parade raises funds and awareness for this agency. (Courtesy of John Wright Jr.)

Five

RELIGION AND HOUSING

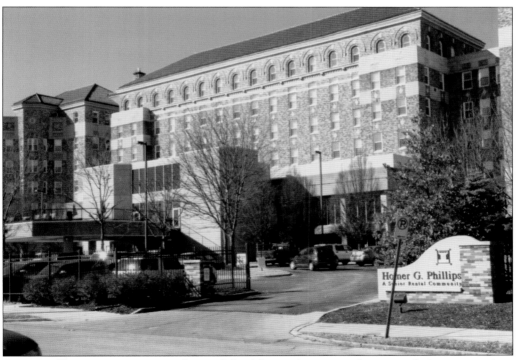

A nationally prominent training hospital for African American physicians during segregation, Homer G. Philips Hospital was closed in 1979, despite protests from the community. In 1994, the hospital reopened its doors as a senior residential facility offering an array of services to its occupants. (Courtesy of John Wright Sr.)

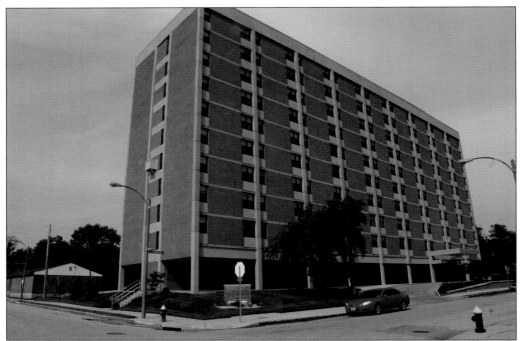

The St. James African Methodist Episcopal Church purchased the Poro Building in 1965. The church then replaced it with James House, a senior residential facility. This 10-story apartment building on the corner of Billups and St. Ferdinand Avenues is part of a "turnkey" project sponsored by the US Office of Housing and Urban Development. More than 200 self-sufficient seniors now reside at James House. (Courtesy of John Wright Sr.)

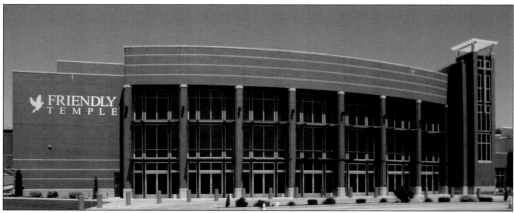

Friendly Temple Missionary Baptist Church is committed to proclaiming the gospel by using the church as an instrument of positive change within people and their communities. Numerous church and community programs facilitate this goal. In addition to spiritual outreach, the church has extensively developed housing units and properties around the building. (Courtesy of John Wright Jr.)

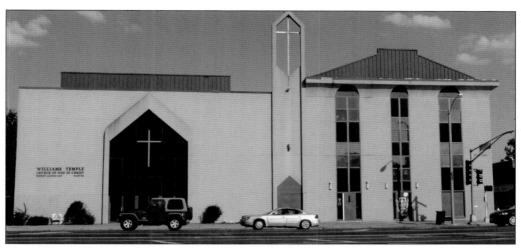

The Williams Temple Church of God in Christ has been a stabilizing force in the community through its multiple service ministries. The church began as a storefront and is now in its eighth location, at 1500 North Union Boulevard. Under Pastor Bishop Lawrence Wooten, Williams Temple has a functional community outreach program that offers food, housing assistance, parenting classes, GED classes, and job training. (Courtesy of John Wright Sr.)

Central Baptist Church, organized in 1847 by Rev. John Richard Anderson, is the fourth oldest black church in St. Louis. It was destroyed by fire in 1974. The congregation voted to rebuild and remain in the city. Today, the church offers an array of services to the community, including the nonprofit Fresh Produce Co-Op, for its members and the community. (Courtesy of John Wright Sr.)

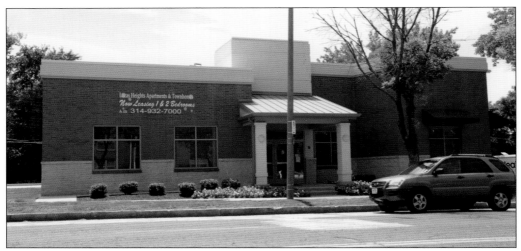

Washington Metropolitan African Methodist Episcopal Zion Church, under the leadership of the Rev. Richard Fisher, sponsored the construction of the Lucas Heights and Metropolitan Village housing, more than 300 units of rental apartments and townhouses. The church is the oldest African Methodist Episcopal Zion Church in St. Louis. It was organized in the 1870s. (Courtesy of John A. Wright Sr.)

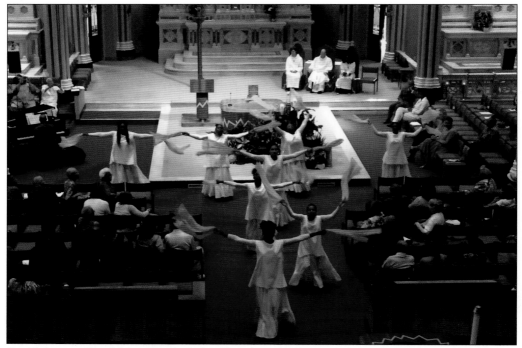

St. Alphonsus "Rock" Ligouri Catholic Church is a Redemptorist parish, practicing Catholicism in the African American tradition. In 1978, under Pastor Father Robert Wirth, the church began a 12-year renovation, adopting an African motif. The church's diverse congregation enjoys mass celebrations that can include liturgical dancing, gospel hymns, and spirituals. The "Rock church" has received national recognition for its worship services and community outreach. (Courtesy of John Wright Jr.)

The first of four apartment complexes developed by Epsilon Lambda chapter, Alpha Phi Alpha fraternity, was Alpha Gardens. Opened in 1969, Alpha Gardens was developed for low- and moderate-income tenants. By 1970, Alpha Towne and Alpha Village Apartments had been opened as well. Alpha Gardens included one-, two-, three-, and four-bedroom apartments. This was the fraternity's first project under its National Building Foundation. (Courtesy of John Wright Sr.)

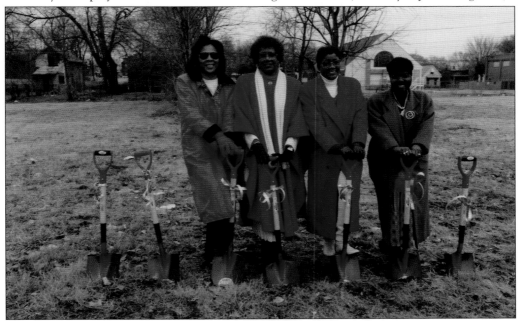

The lack of housing maintenance in the 4300 and 4400 blocks of Maffitt Avenue had deteriorated the area. However, thanks to the efforts of Delta Sigma Theta sorority and Habitat for Humanity working in partnership, new homes now stand in the place of blighted housing. Here, Deltas are seen at the ground breaking of this development. (Courtesy of Michelle Price.)

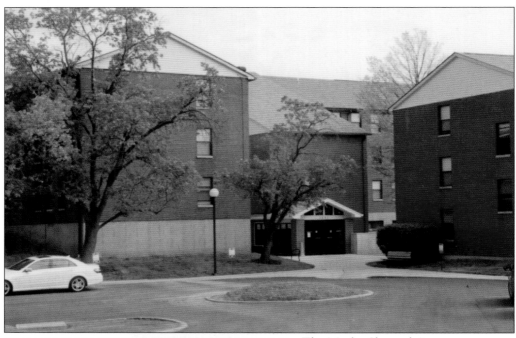

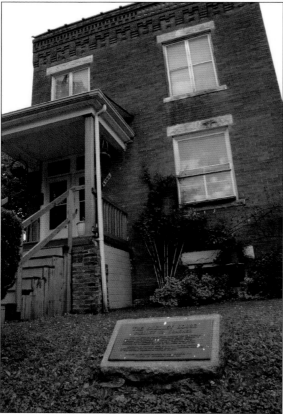

The Macler Shepard Apartments are named to honor Macler Shepard, a legendary housing advocate and founder of Jeff-Vander-Lou in 1966. Shepard, an expert on federal housing policy and the housing needs of low income residents, played a major role in the redevelopment of the area. He was honored for his efforts in restoring the Scott Joplin House. (Courtesy of John A. Wright Sr.)

In 1939, J.D. Shelly and his wife purchased this home, and a lawsuit was filed against them by white neighbors to prevent their ownership. The case, *Shelly v Kramer*, went all the way to the US Supreme Court, whose decision ended race restrictive covenants nationally. In May 1988, Girl Friends placed a marker to honor the 40th anniversary of the court decision. (Courtesy of John Wright Sr.)

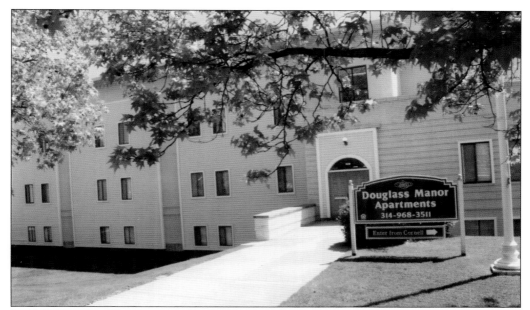

In 1967, Douglass Elementary School in the Webster Groves School District, once an African American school, became one of two integrated demonstration schools. In 1978, Douglass Elementary closed due to decreased enrollment, but in 1983, the site was refurbished as Douglass Manor Apartments. It is a 41-unit subsidized housing complex for older adults and disabled families. (Courtesy of John Wright Sr.)

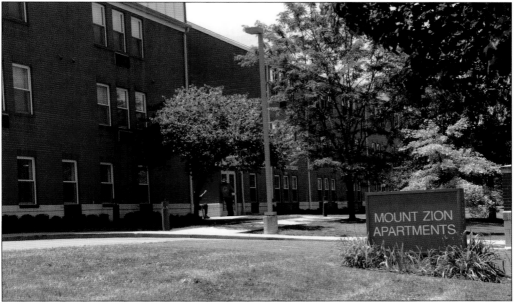

Mount Zion Missionary Baptist Church is responsible for the construction of these affordable senior one-bedroom units in 2002. The church was organized in 1859 as the Mount Zion Church, served by Rev. Wyatt Scott. The church's neighborhood development seeks to provide holistic services to the community surrounding the Mount Zion Christian complex. (Courtesy of John A. Wright Sr.)

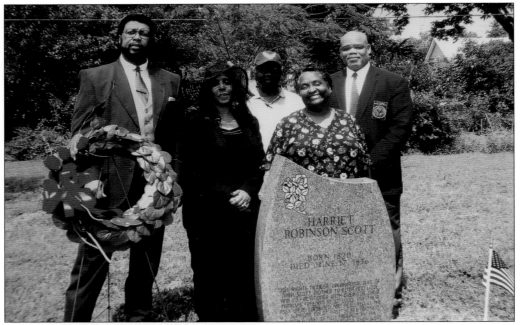

Harriet Scott and her husband, Dred Scott, were named plaintiffs in a lawsuit that changed the course of American history. The Scotts' case was a major contributing factor leading to the Civil War. After more than a century, the grave of Harriet Scott remained unmarked. Once the grave was located, her descendants gathered to honor her gravesite with a headstone. (Courtesy of Lynn Jackson.)

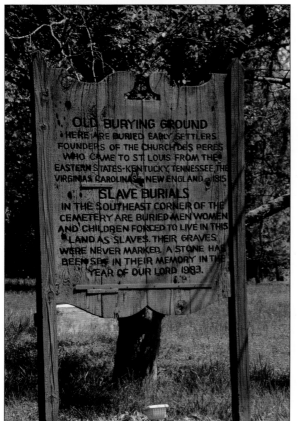

Many former African American slaves lay in unmarked graves around the metropolitan area. Here is one identified resting placed. Its plaque reads in part, "In the southeast corner of the cemetery are buried men, women, and children who were forced to live in this land as slaves." (Courtesy of John Wright Sr.)

Young Yaheed McCurry celebrates his bar mitzvah at the Central Reform Congregation in St. Louis. This celebration marks the coming of age of a young man, as they are now seen to be old enough to take responsibility for their actions. This celebration also means accepting the Jewish laws, traditions, and ethics that will enable the person to fully participate in Jewish society. (Courtesy of Angela McCurry.)

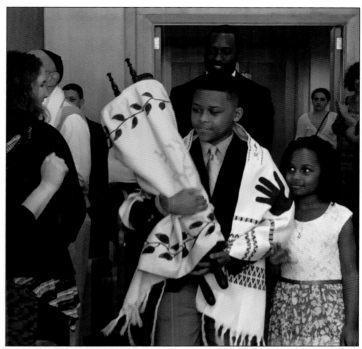

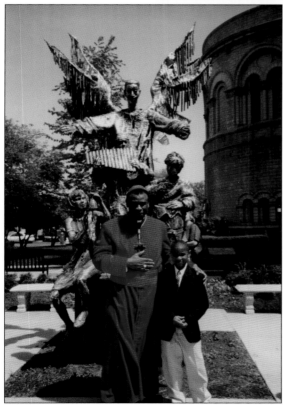

African American Auxiliary Bishop Edward Braxton is pictured with a parishioner in front of the *Angel of Harmony* statue, which he proposed in 1999. The statue may be the first ever commissioned by the archdiocese that depicts an angel with African American features. Standing in front of the angel are three children with Asian, Hispanic, and European features. (Courtesy of John Wright Sr.)

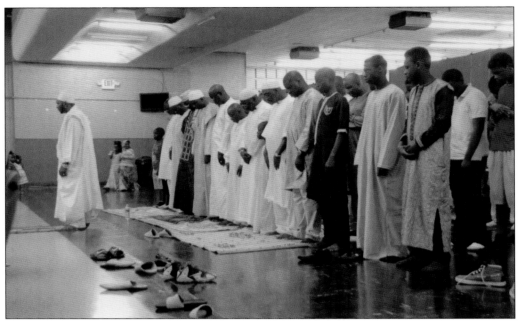

The St. Louis African American community includes many practicing Muslims. While all who practice Islam do not dress the same, all devoted Muslims answer the call for prayer. This can take place in group settings or individually. Here, a group of men have gathered for worship. (Courtesy of John Wright Sr.)

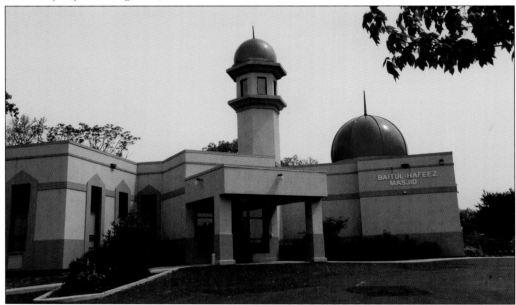

The Muslim places of worship can be varied in appearance. Some mosques in St. Louis's African American communities reflect Middle Eastern architecture, while others do not. To be considered a mosque, a building must adhere to strict requirements in keeping with Islam. Mosques are not only places of worship, but are centers for community gatherings, education, and information. (Courtesy of John Wright Sr.)

Six

CHALLENGES

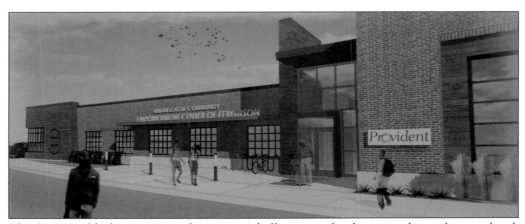

The St. Louis black community faces many challenges in the days, months, and years ahead, including high unemployment, failing schools, and a lack of accessibility to quality schools and health care. For the city to reach its full potential, these challenges must be met. To address the issues of unemployment and underemployment, the Urban League of Metropolitan St. Louis is building this Community Employment Center in Ferguson. (Courtesy of John A. Wright.)

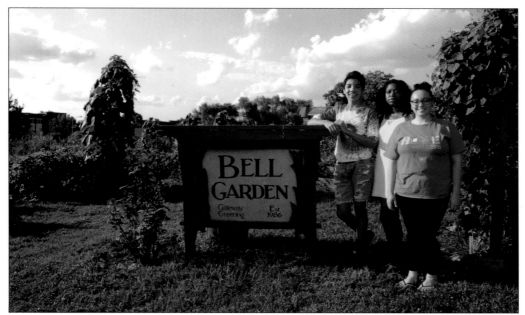

Many consider black communities food deserts, due to the unavailability of quality food. Major grocery chains have abandoned these communities, and fast-food chains have taken their place. To fill the void, many communities have developed gardens, like the one pictured here, to provide healthy choices for residents. (Courtesy of John A. Wright Sr.)

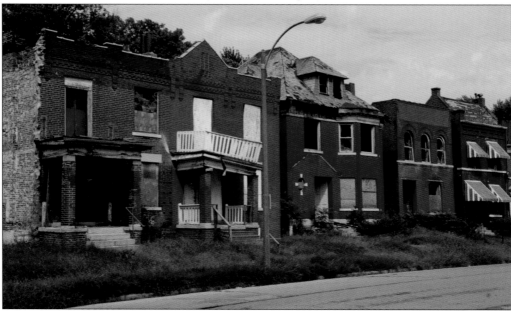

For many African American citizens, decent housing is still a real issue. Many residents are forced to live in neighborhoods lined with decaying and unsafe structures, such as those pictured here. Those who are given the opportunity to flee these conditions often fall prey to unscrupulous institutions. Decent housing must be provided for all if the city is to thrive. (Courtesy of John A. Wright Sr.)

In 2007, the state appointed a three-member board to operate the St. Louis Public Schools, which had failed to meet minimum state standards. In 2008, Dr. Kelvin Adams was appointed superintendent, charged with the difficult task of turning the district around. As the present conditions did not happen overnight, realizing the desired goals will take time. (Courtesy of St. Louis Board of Education.)

Judge Jimmy Edwards, out of concern for youngsters who came before his court, established the Innovative Concept Academy in the fall of 2009. The academy is the only school in America overseen by a court dedicated to the education and rehabilitation of delinquent teens. It offers a chance to break the cycle of failure for many youngsters. (Courtesy of Jimmy Edwards.)

As a community, residents must celebrate academic excellence as much as they do excellence in athletics. In spite of the many obstacles put before the African American community, there are unlimited opportunities for those who further their education. The Sankofa ceremony at Saint Louis University (pictured) was designed to celebrate the achievements of the school's black graduates. (Courtesy of Stefen Bradley.)

Recent studies have shown that the present justice system is not color-blind. While the African American population is in the minority, it is disproportionately affected by the justice system. Racial disparities in the courts have contributed to unfair sentencing, unemployment, family breakups, poor education, and housing difficulties. In order for the community to thrive, change must take place. (Courtesy of John A. Wright Sr.)

This bronze statue of Christopher Harris, an African American boy, stands outside Cardinal Glennon Children's Hospital. Harris was murdered in 1991 while being used as a human shield. The bronze statue is filled with melted handguns used in crimes. Words at the base of the statue of the barefoot, smiling boy read, in part, "In loving memory of all young people who die from violence." (Courtesy of John A. Wright Jr.)

In order to achieve the goal of a better and brighter future for the city, it is going to take everyone working together. No longer can separate and unequal societies be maintained. There is a need to join hands and march until, together, the residents of the St. Louis metropolitan area reach the goal of one community, with liberty and justice for all. (Courtesy of John A. Wright Jr.)

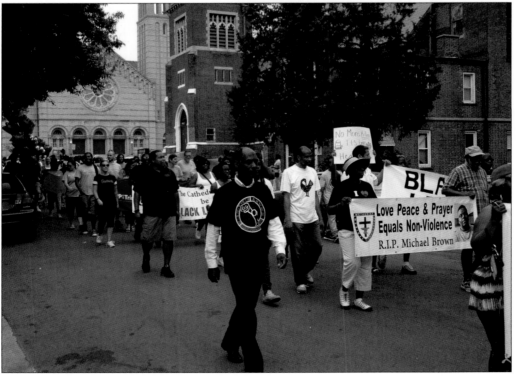

DISCOVER THOUSANDS OF LOCAL HISTORY BOOKS
FEATURING MILLIONS OF VINTAGE IMAGES

Arcadia Publishing, the leading local history publisher in the United States, is committed to making history accessible and meaningful through publishing books that celebrate and preserve the heritage of America's people and places.

Find more books like this at
www.arcadiapublishing.com

Search for your hometown history, your old stomping grounds, and even your favorite sports team.

Consistent with our mission to preserve history on a local level, this book was printed in South Carolina on American-made paper and manufactured entirely in the United States. Products carrying the accredited Forest Stewardship Council (FSC) label are printed on 100 percent FSC-certified paper.

MADE IN THE USA